DRAW COMICS LIKE A PRO

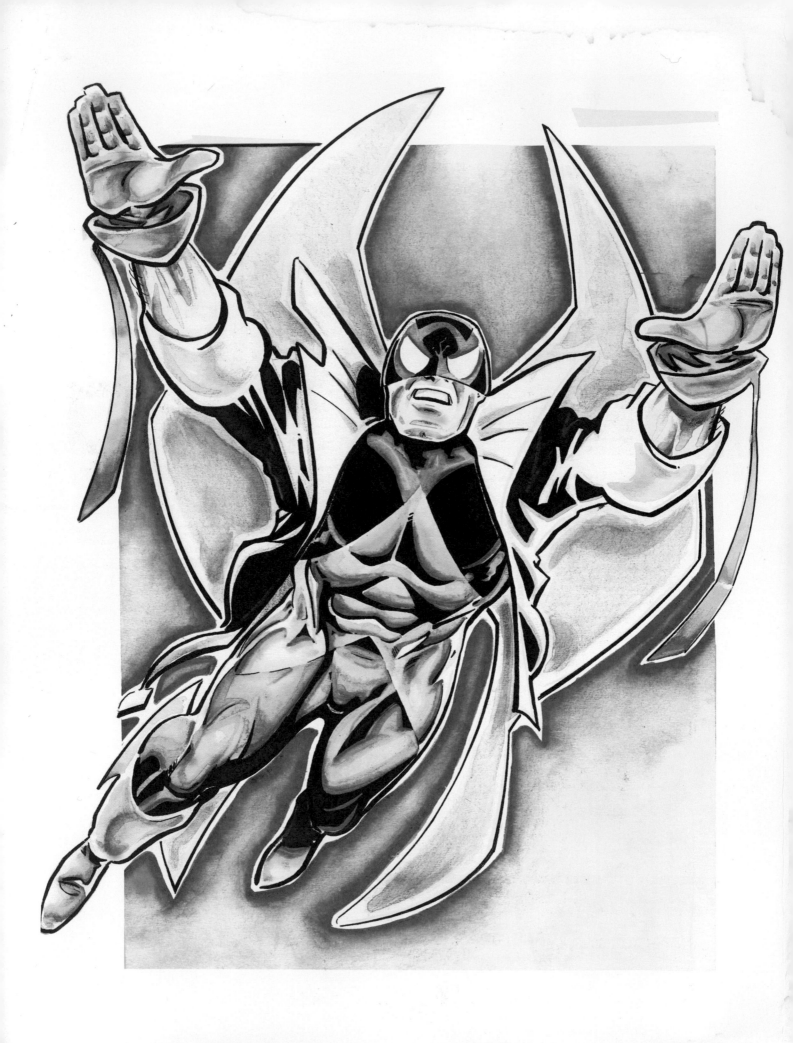

DRAW COMICS LIKE A PRO

TECHNIQUES FOR CREATING DYNAMIC CHARACTERS, SCENES, AND STORIES

Al Bigley

WATSON-GUPTILL PUBLICATIONS NEW YORK

Text and art copyright © 2007 by Al Bigley

Editorial Director: Victoria Craven
Editor: James Waller
Designer: Kapo Ng@A-Men Project

First published on 2007 by Watson-Guptill Publications,
Nielsen Business Media,
a division of The Nielsen Company
770 Broadway, New York, NY 10003
www.watsonguptill.com

Library of Congress Control Number: 2007936035

Printed in China
First printing, 2007
1 2 3 4 5 6 7 8 9/10 09 08 07

ACKNOWLEDGMENTS

I'd like to thank the following people for making this book possible:
Jackie Ching, Victoria Craven, Andy Smith, Bess Forshaw, Terry Collins, Steve Haynie,
Dan Schaeffer, Scott Kress, Don Bigley, and the students at the Drawing Room.

CONTEN

THERE'S A GALAXY FULL OF SUFFERING...

DON'T MUCH E?

I MISS YOU... ELIZABETH ...

TS

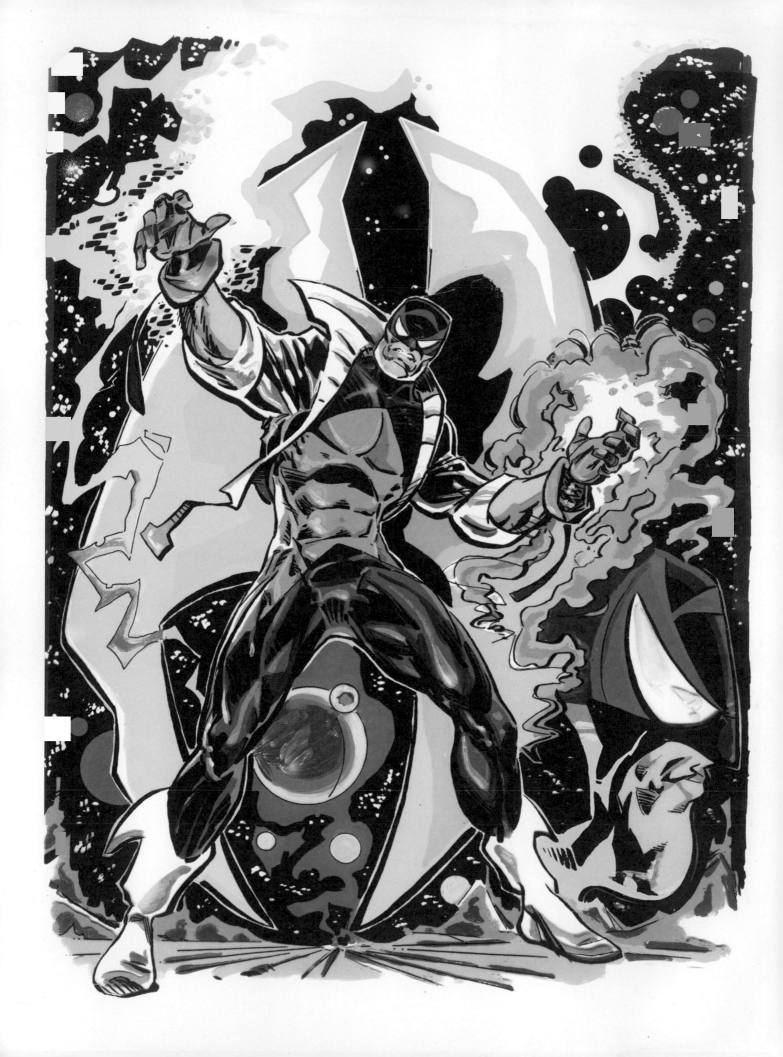

GEMINAR

So you already know the basics of comic art and can draw dynamic characters and fantastic figures? Well, stick with me to learn all about those little extras, tricks, and professional secrets that will take your art to the next level. By the way, my name's Geminar, and you'll be seeing a lot of me. So let's get started!

BODY LANGUAGE

Body language, or **figure gesture**, is the overall **pose** of the figure. Even without seeing the face or facial expression of a character, the viewer can tell what that character is feeling. The character may be far away, or viewed from behind, or hidden in shadow—but body language can communicate a lot about his mood.

Human beings show so much **emotion** just through how they hold their hands and body that sometimes that's all you need to see to understand their situation and attitude. But adding **cartooning icons** and **special effect symbols** can give the viewer even more information! "Steam squiggles" can indicate anger; stars can indicate confusion; and various lines can show different kinds of motion.

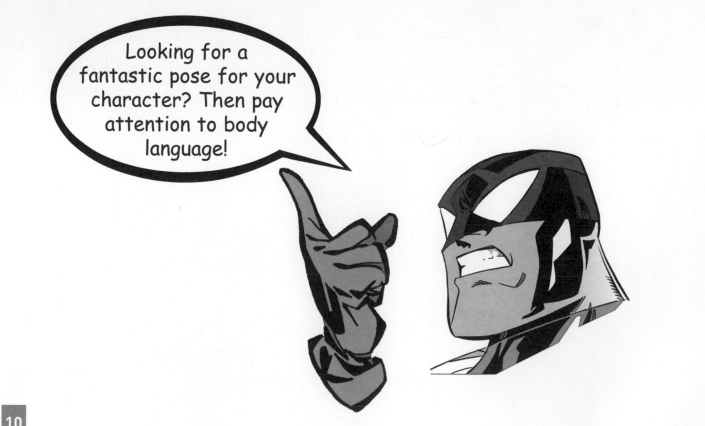

Looking for a fantastic pose for your character? Then pay attention to body language!

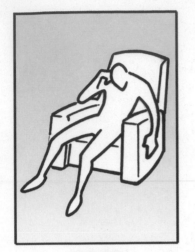

TIRED

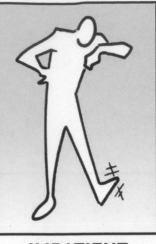

IMPATIENT

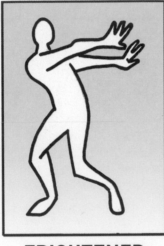

FRIGHTENED

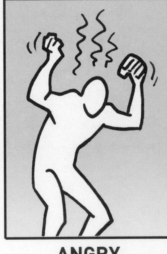

ANGRY

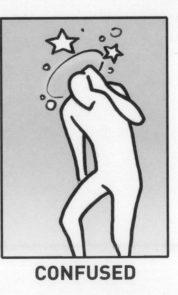

SURPRISED

CONFUSED

Here are some more examples of how to use body language to emphasize a mood or attitude. In these cases, the feeling is one of isolation and sadness. You don't really need words or captions to recognize the mood being conveyed, because you can "read" what the character is feeling through his body language.

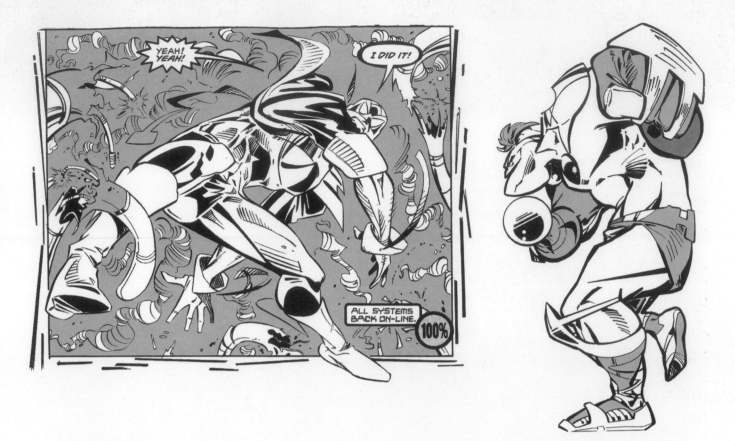

Body language can also help you design poses that effectively communicate energy and strength. Just look at how powerful and energetic these examples are! They all convey might and motion without the viewer seeing the characters' faces in any detail!

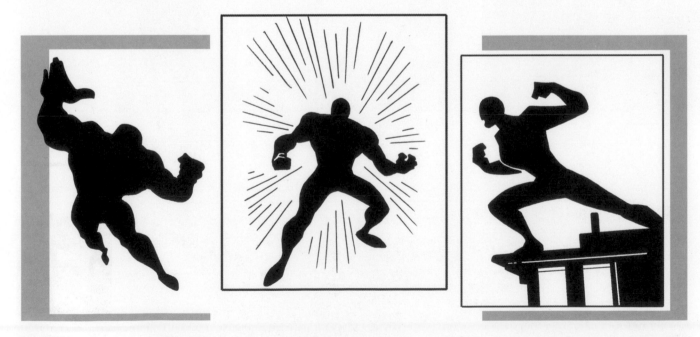

Figures seen only in **silhouette**, like the ones above, can appear extremely strong and bold because they're all about attitude and feeling—*not* costume details or fancy drawing techniques. Very attention-grabbing!

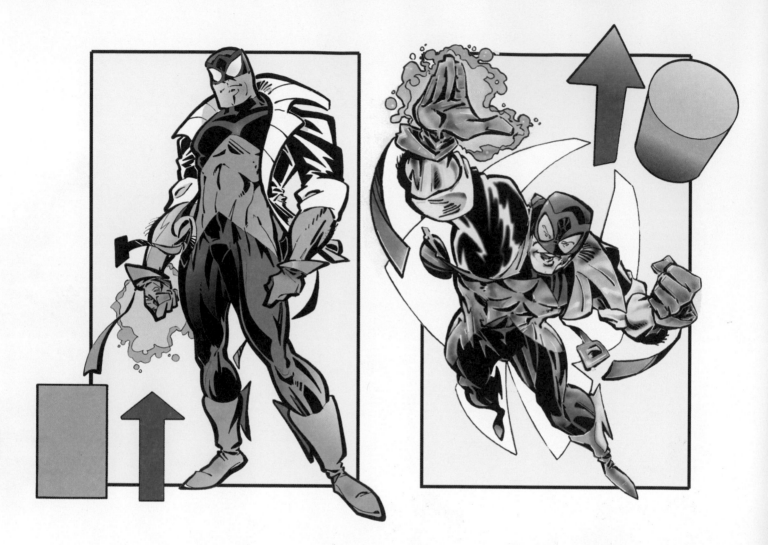

The term *foreshortening* describes what happens when a figure or object is drawn in **extreme perspective.** When a figure is foreshortened, some elements appear to be very close to the viewer, while others are farther back or even completely hidden from view—just as we see things in real life. Foreshortening can also refer to the way a form appears shorter when it's tilted toward or away from the viewer.

 Notice how exciting the foreshortened figure on the right is. He seems to be bursting into sudden movement and activity. Foreshortening gives this drawing an illusion of thickness and **depth,** as if the character really exists in **three dimensions.** To get a quick idea of how foreshortening works, take an ordinary tin can and look at it straight on from the side. See how flat it appears? Now tilt it slightly toward you and watch how it gains dimension and depth.

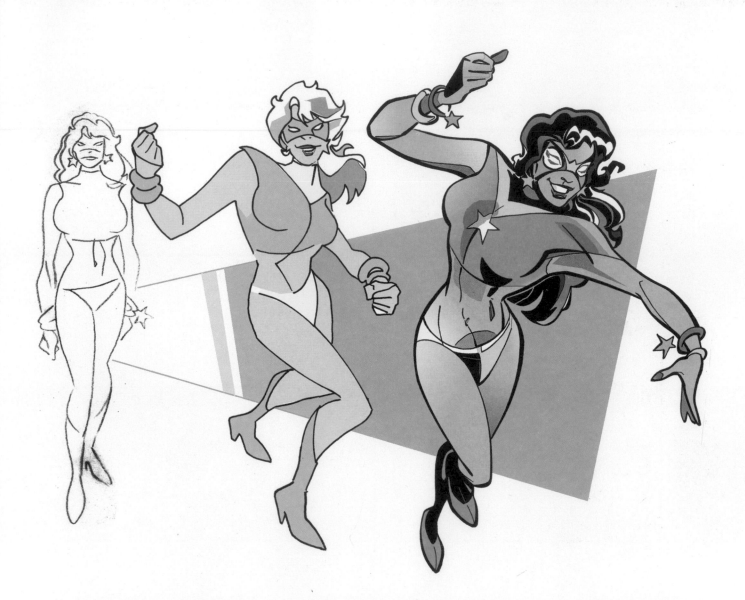

Here we see how to depict a dynamic superhero moving into action. Notice how flat and "straight on" she appears in the first view, on the left. That's fine, of course, but it's not very exciting. It doesn't move or "pop" off the page. The middle figure is slightly foreshortened—and begins to come to life—but the final one, on the right, really bursts into action! The extreme perspective makes our female superhero seem much more animated and alive, giving her figure a sense of **exaggerated reality** that's very important in comics.

In real life, we rarely see people just standing still right in front of us. Usually, they're moving toward or away from us—or we're seeing them from an angle. And the same goes for objects: we're always looking at the world from a certain **perspective** that gives people and objects dimension and depth. So stay away from those boring "straight on" views! Use foreshortening and move the scene around to view it from different angles to make your figures seem much more realistic.

TIP: Don't be afraid to use a friend as a model to get more realism into your drawings. You can even use a mirror to study how your own body looks in certain poses and from different angles.

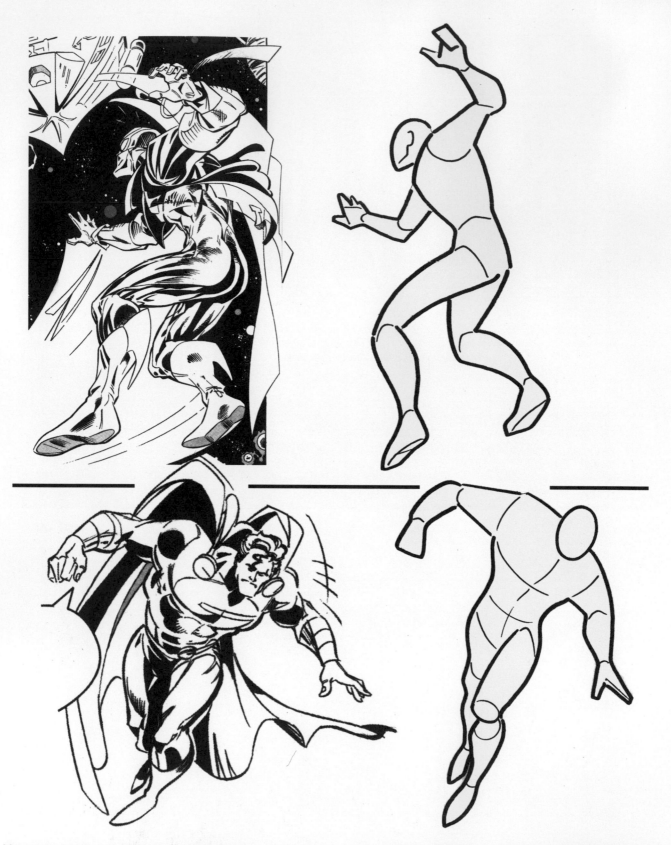

You can easily construct any foreshortened figure by using **simple shapes** as the basic building blocks of your drawing. Think of your figures as if they were mannequins, and construct them with **ovals, cylinders, squares,** and **rectangles.** In the early stages of a drawing, don't worry about surface details. Keep it simple! Here are a few foreshortened figures, along with simple drawings showing how they were put together in the **sketch** stage.

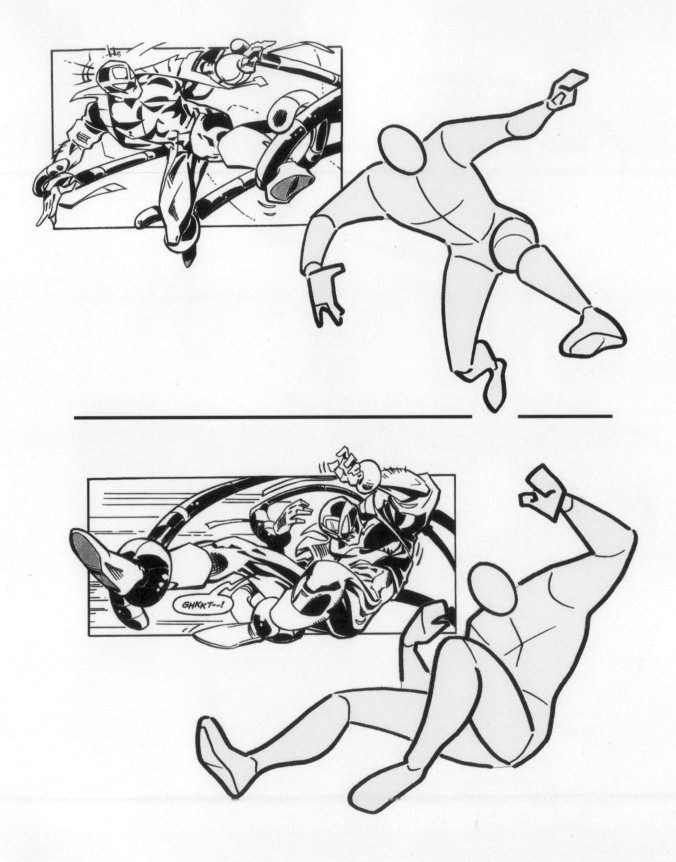

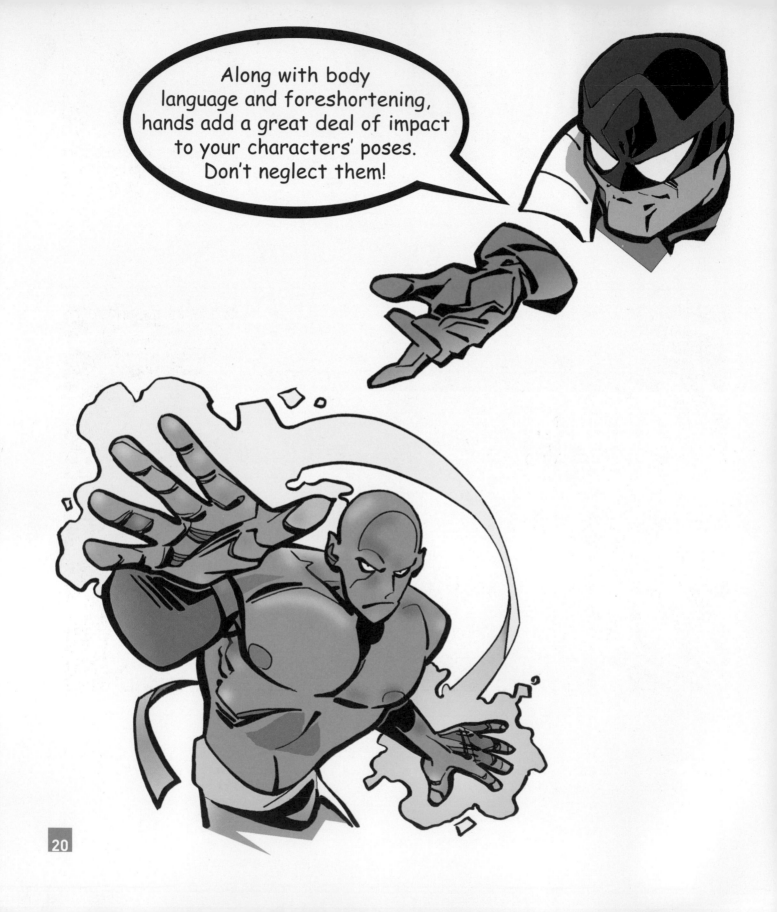

Other than the face, the hands tell us the most about a character's attitude and emotion. The placement of the hands also enhances facial expressions and body language. Notice how much more feeling and **drama** the addition of expressive hands adds to the overall mood in these images.

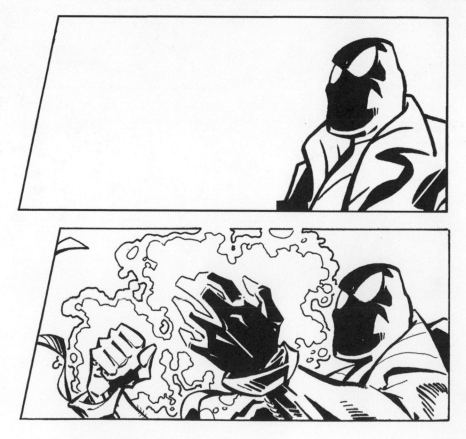

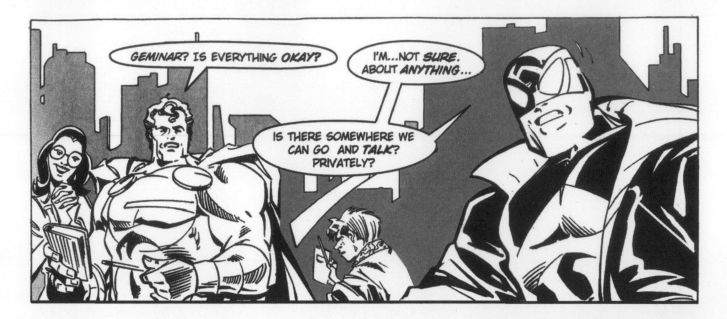

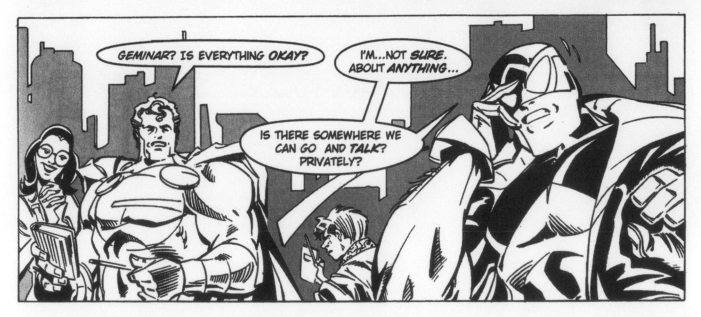

TIP: Again, if you're having trouble coming up with a pose or getting it just right, ask a friend to pose for you, pose yourself in front of a mirror, or look in magazines or on the Internet for a good photo that you can use as a reference.

Proportion refers to how the different parts of the body relate to each other in size. If you're drawing a realistic character, the hands have to be bigger than the nose, and the head has to be bigger than the toes! But when you want your heroes and monsters to look strange and different, you may want to deliberately draw them **out of proportion,** and that can be a lot of fun! A head that's smaller than normal can make a figure's body seem bigger and stronger. A head that's too big can make the whole character seem scrawny and thin.

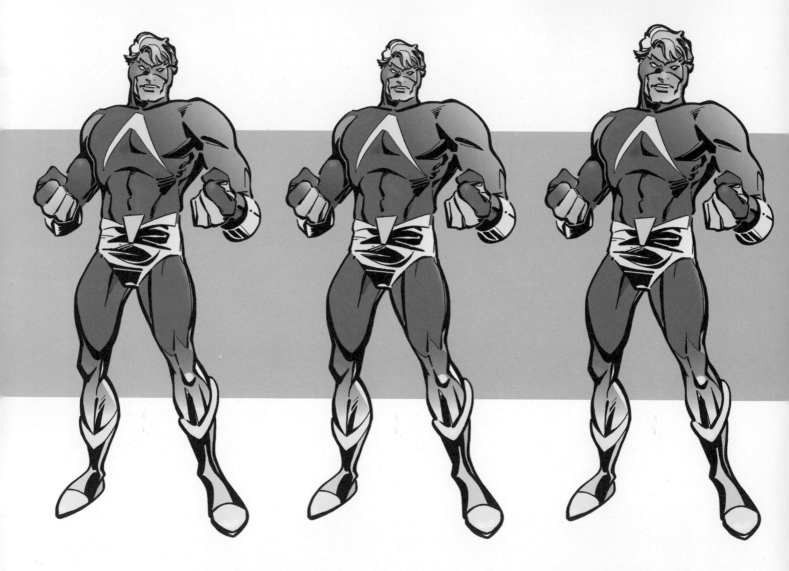

Take a look at this specimen. The first figure, on the left, seems just right for a normal superhero—buff and ready for battle. The middle figure, however, looks like a huge, muscular monster. And the guy on the right looks kind of short and shrimpy—even though he's obviously well muscled. And what's the only thing that's been changed from figure to figure? The head size!

Use large hands for a character who uses his fists a lot! A super-size head for a super-smart genius villain! Oversized feet for a super-speedy runner! What similar ideas can *you* think of?

Relative size refers to the size of one figure **in relation to** another. For instance, we know that the attacking monster in this panel is huge, and not just because of how tiny his head is in relation to his body. There's another clue to just how gigantic this guy is—which is that he's bigger than the hero in the foreground even though he's several steps behind! The distance between the figures is established through the use of **overlapping.** Notice how the hero's head overlaps the monster's leg, letting us know that the hero is closer to us and creating a realistic sense of depth.

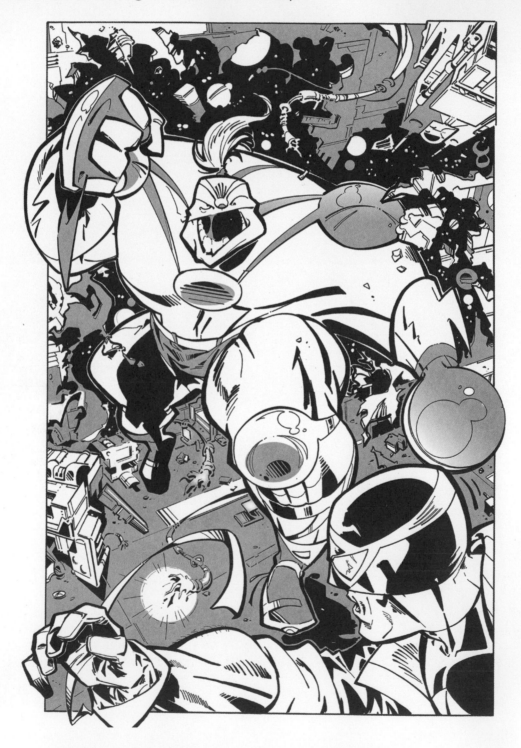

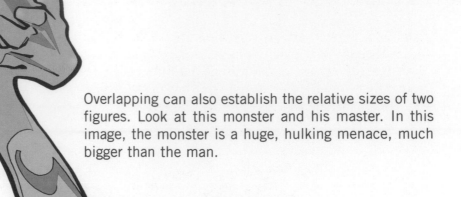

Overlapping can also establish the relative sizes of two figures. Look at this monster and his master. In this image, the monster is a huge, hulking menace, much bigger than the man.

But take the same monster figure and put him in front of his master. Now he seems a mere toy! Because our eye automatically assumes that the normal-looking guy in these images is the size of a "normal" man, we can easily establish the monster's size by overlapping. If we put the man in front of the looming monster, we know that the monster must be *huge*. But if we put the monster in front of the man, the monster looks doll size.

Think about how video and movie directors use close-ups. The camera **zooms** in when something important and attention-grabbing is happening. It captures an action, a reaction, a gesture, or a facial expression at very close range.

ONCE AGAIN, THE DECISION WAS MINE. I KNEW THIS WAS MY ONLY CHANCE TO EVER RETURN **HOME**. WHAT CHOICE DID I HAVE IF WHAT I WAS BEING TOLD WAS **TRUE?**

I ACCEPT.

That's how close-ups are used in comics, too—as a way of letting the reader know what's most significant. In these close-up shots, you can certainly tell what the characters are feeling, since it's easy to read their **facial expressions** when we're pulled in so close.

Close in on what you think is the most important and meaningful part of your drawing. Is it a face? A figure? An object? A fist?

The scene opposite depicts an intense struggle as a hero tries to lift a heavy object to save a trapped friend. Notice how the scene's panels include several close-ups, each giving the viewer a piece of crucial information and adding to the drama and emotion of the moment!

A close-up forces readers to **focus** their attention on what you want them to see. It says, "You *must* look at this!"

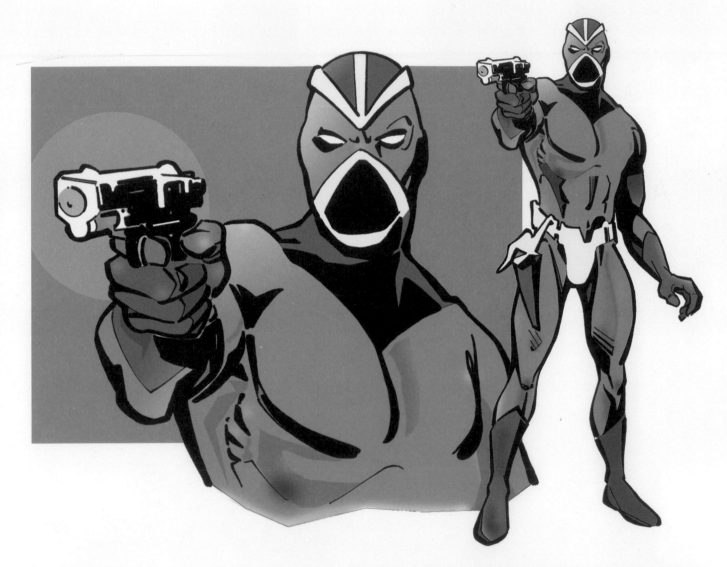

The close-up in this "double" view of a bad guy pointing a gun serves two purposes. Not only does it enable us to see the villain better, but it puts the **emphasis** on the gun and the danger it represents. The full-figure view is cool, but it just doesn't have the visual **impact** of the close-up.

COOL COMPOSITIONS

Just look at how interesting this **composition** is. A super-gal is trapped against a wall by a looming super-foe, and her form is **framed** by his dark, threatening, and much larger shadow. Because she's framed in this way, you immediately get the feeling that she's boxed into a very dangerous situation. The scene's tension is heightened by the composition itself.

How you arrange the elements in a drawing can really add to its impact!

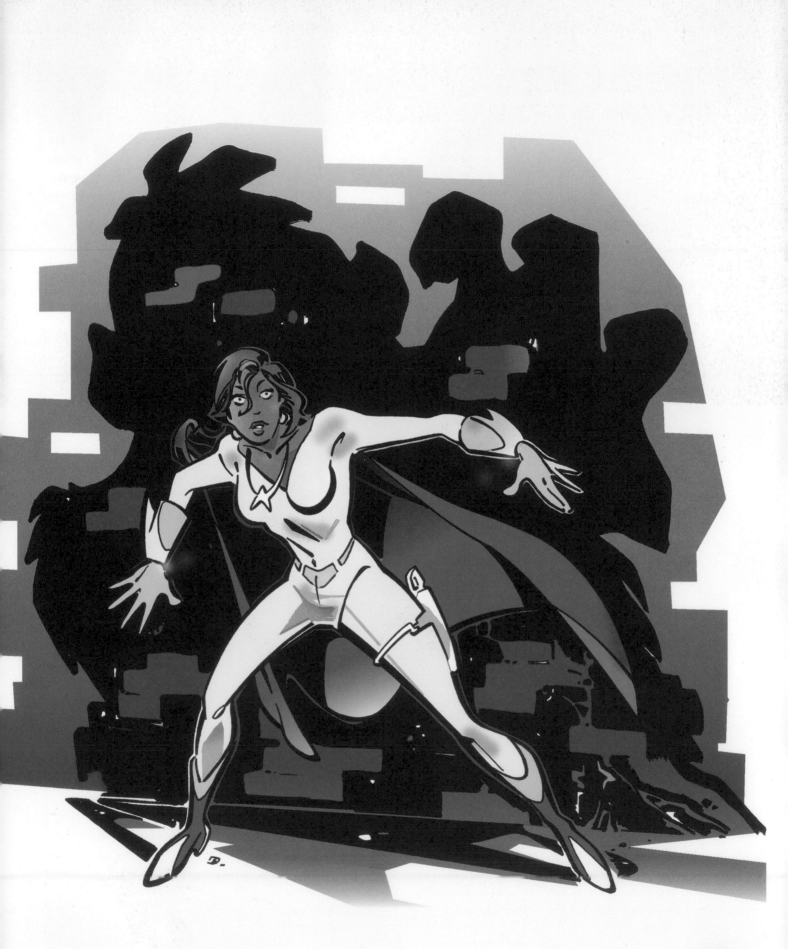

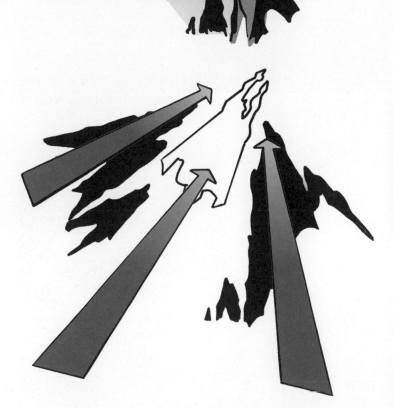

Good compositions can tell the viewer what's vital in your drawing by framing the interesting or important elements or by leading the eye to move in a certain direction across the image.

Look how the mountain ridges **frame** the flying hero in this shot. They also point upward, adding to the feeling of movement in that direction. And, once again, body language is crucial: because the flying guy is drawn in a straight, pointed pose, he points upward, too!

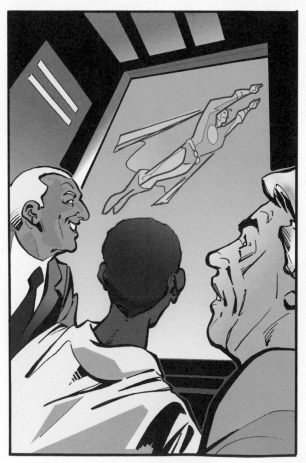

In the variation at right, the same flying hero is framed by the window as well as by the onlookers grouped around his form. The perspective makes the window frame seem to tilt toward him—increasing the sensation of upward movement.

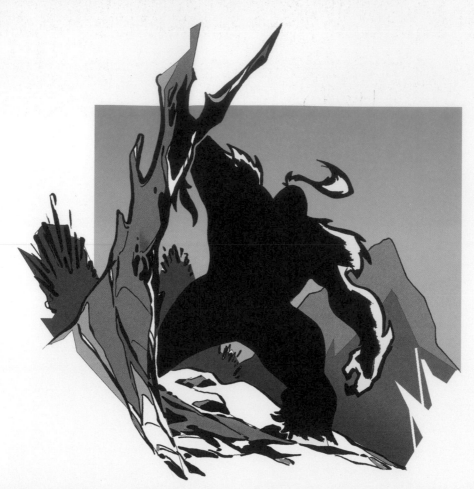

Framing a character doesn't necessarily require an actual frame. Look, for example, at how this fearsome snow beast is sort of "framed" by the tree and its shadow—and how his silhouette makes him become part of the shadow.

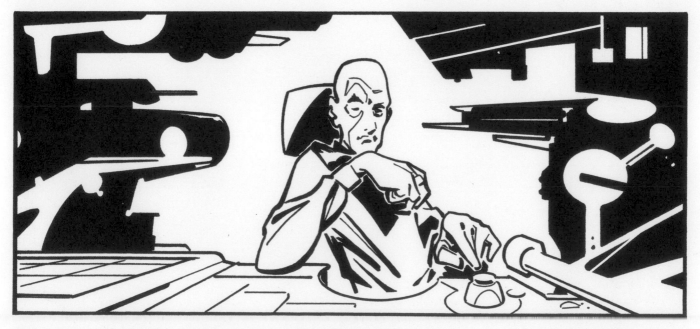

And here's a similar idea. Because the machinery surrounding the ghoulish main figure is made of large black shapes, he seems framed by—and trapped within!—the structure.

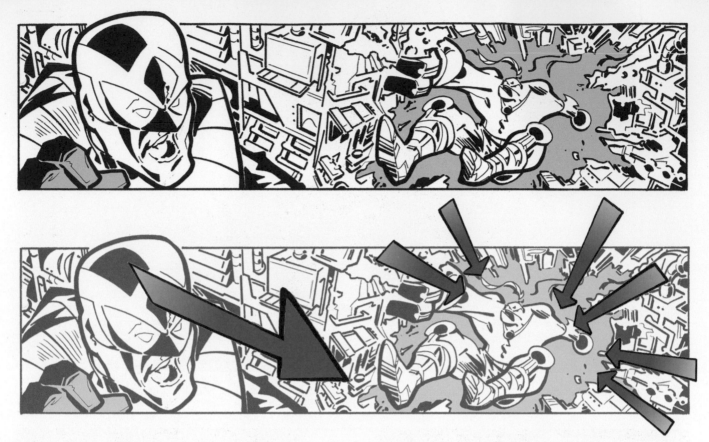

Some compositions tell your eye how to move. Because this panel is laid out **horizontally,** you "read" it from left to right. In addition, all the machinery surrounding the alien figure on the right points to him even as it frames him.

As we follow the pointing gun, this composition leads our eye to the hero who's being threatened. Because the gun is closer to us, it is emphasized—making it seem very important. Just ask the guy it's pointed at!

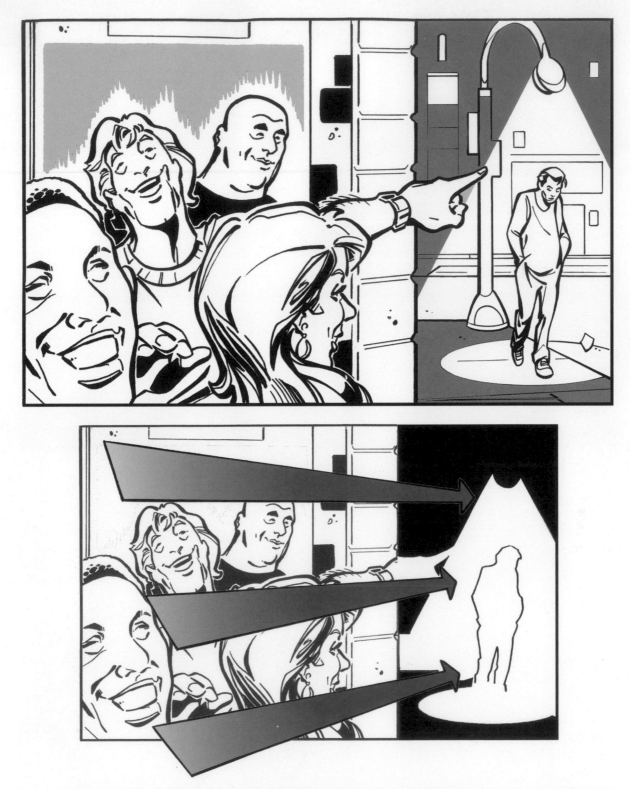

Pointing can be quite literal. Notice how the pointing hand in this panel directs your eye to the lonely guy at the right, who is further isolated from the crowd by the shadow surrounding him and the vertical dividing line of the wall.

Here's another long, horizontal panel. Your eye is drawn across it as you "read" the image from left to right. But that's not all that's going on here. Notice how the machinery on both the left *and* the right frames and points to the figure in the middle.

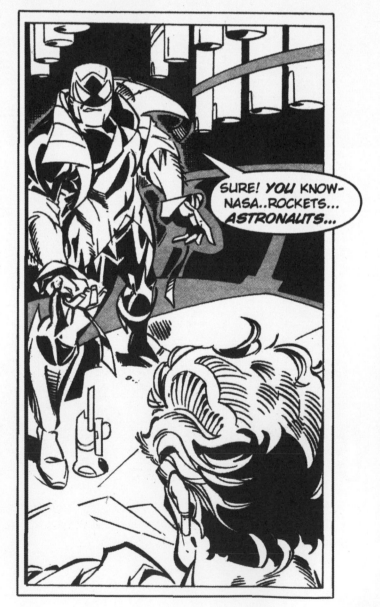

A composition doesn't have to make your eye move from left to right—or even from one side to the other. In this panel, your eye is drawn from the upper portion, and the character who's talking, down to the lower portion, and the friend who's listening.

Inside and Outside the Frame

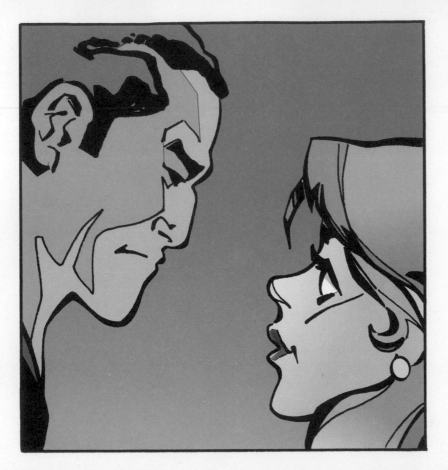

Sometimes framing or cropping an image very tightly can create drama. Look at how a sense of confrontation and tension is created by jamming these two faces so close together. Are he and she arguing? Or are they about to kiss?

In comics, though, you don't always have to respect the boundaries of the frame. The heavy blacks on the left side of this panel begin to frame the spaceship, but the spaceship is actually breaking free of that frame (and of the panel itself). Nice balance!

EFFECTIVE BACKGROUNDS

As we've already seen, adding a background to a figure drawing can help **direct** the viewer's eye to the more important parts of the drawing. But backgrounds do more than just guide the viewer's eye.

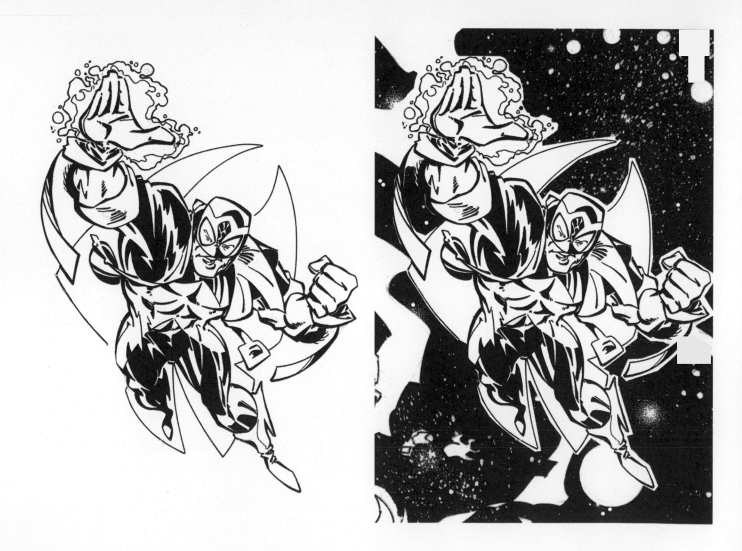

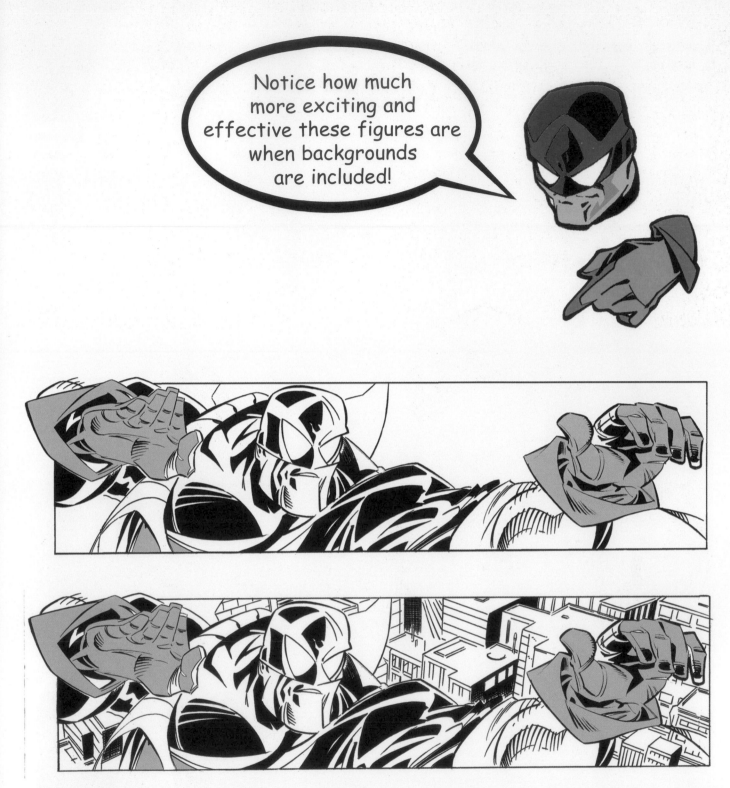

A background can give the viewer essential information about the **setting,** mood, and atmosphere of a scene.

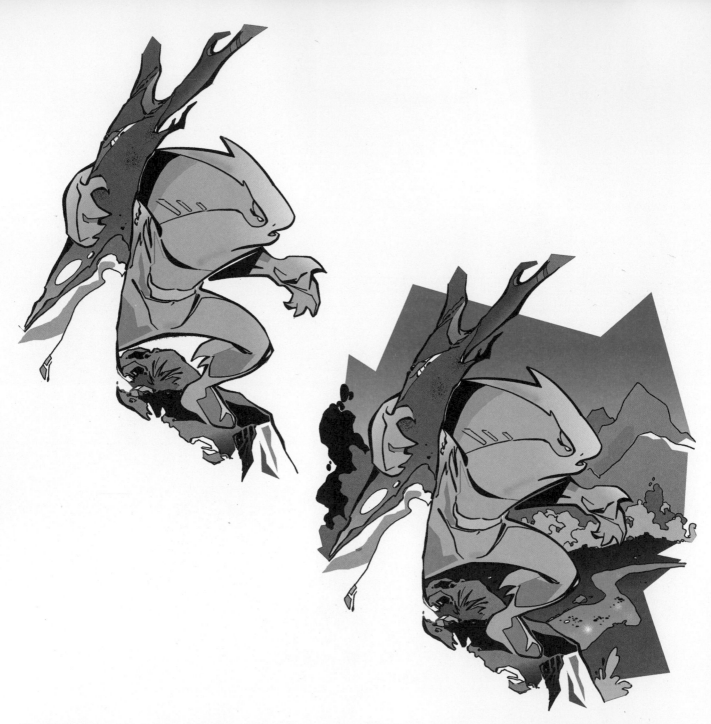

Backgrounds also create a feeling of depth, and this 3-D illusion makes your drawings seem less flat and much more realistic. When figures in the foreground overlap background elements, an important sense of **deep dimension** is created. And, of course, the background gives the reader a good look at where a scene is taking place.

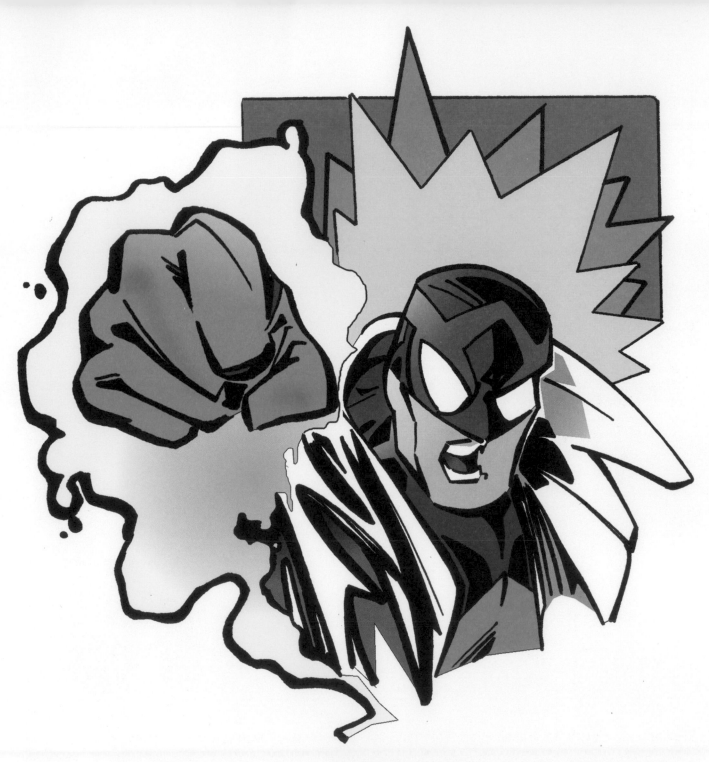

A background does not have to be realistic to add a feeling of depth to a drawing. Abstract background designs can also create the illusion of three-dimensionality.

Having a foreground figure overlap an abstract background can be just as effective in creating depth as using a more realistic background.

Opposite, the background is a villain's menacing shadow—somewhat realistic but also somewhat abstract. The villain has trapped the barbarian warrior, who is framed and engulfed within that ominous, overwhelming shape.

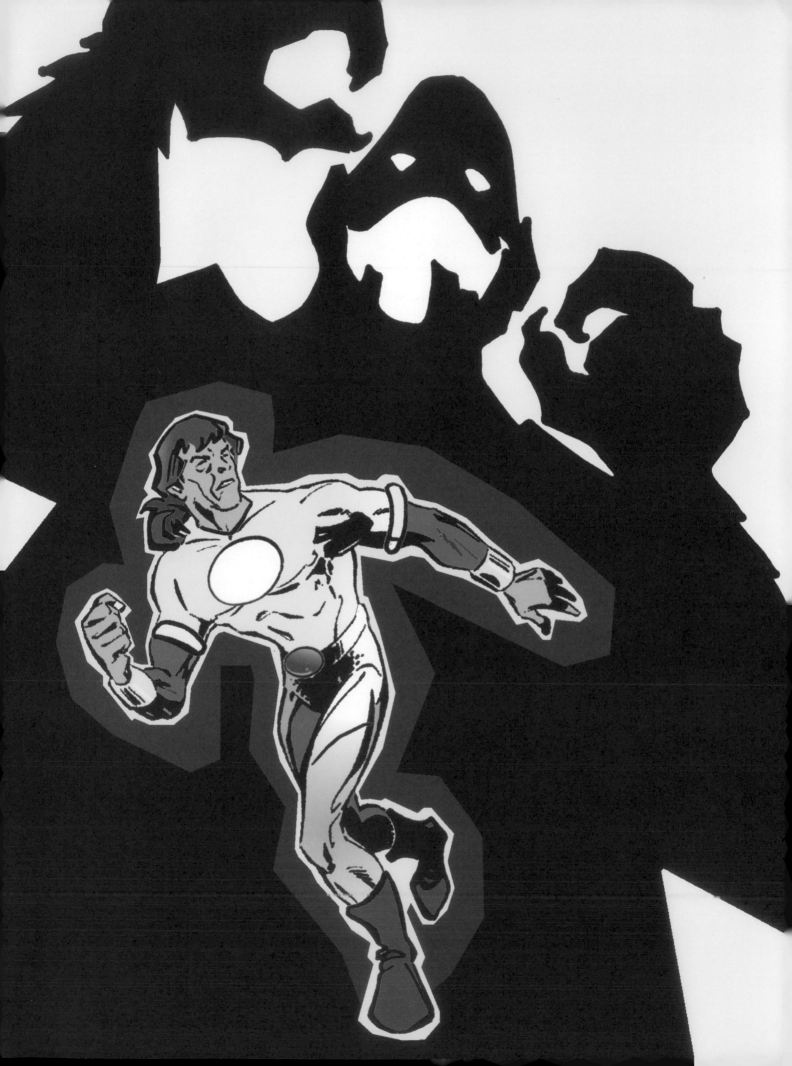

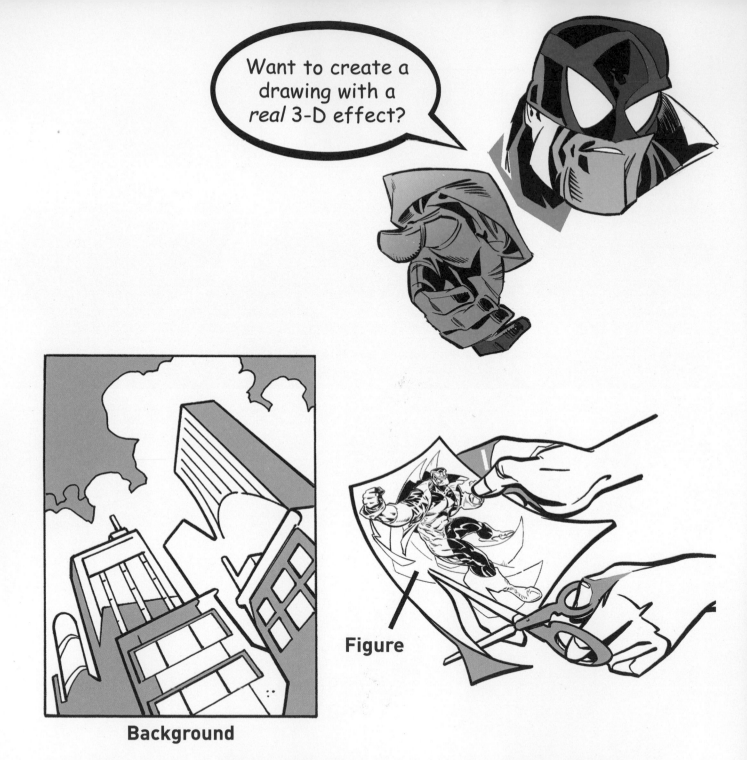

Want to create a drawing with a *real* 3-D effect?

Background

Figure

Try for a real 3-D effect by creating a **"billboard"** drawing. First, draw a complete background on one sheet of paper. Then, on a separate piece of paper, draw your figure, and carefully cut it out with scissors.

Back of figure

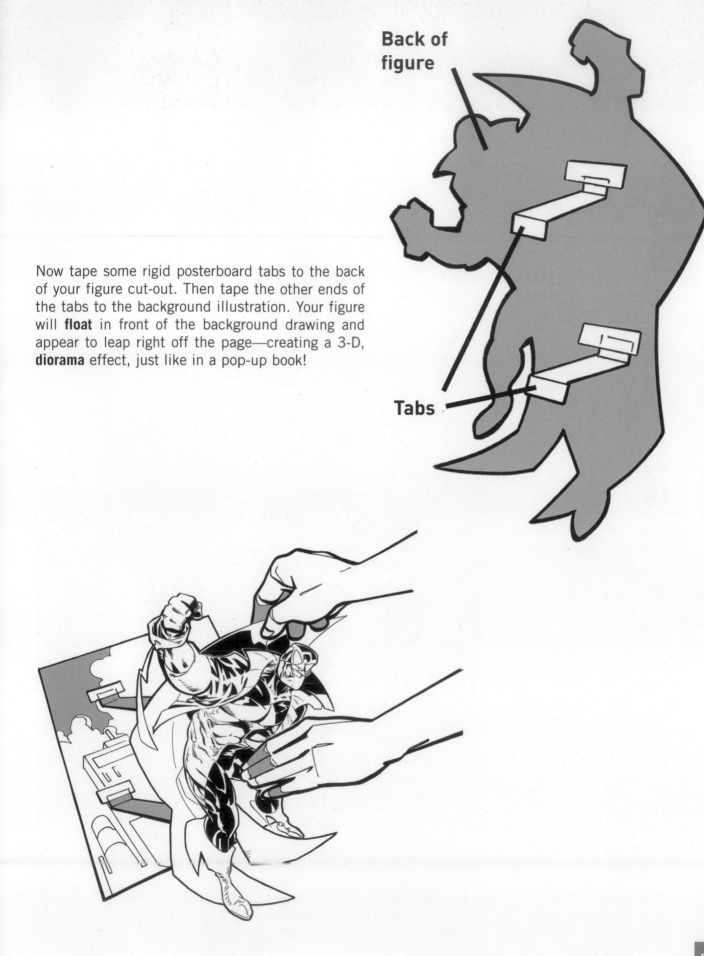

Now tape some rigid posterboard tabs to the back of your figure cut-out. Then tape the other ends of the tabs to the background illustration. Your figure will **float** in front of the background drawing and appear to leap right off the page—creating a 3-D, **diorama** effect, just like in a pop-up book!

Tabs

Another exciting background effect involves using real pictures. Find interesting images in newspapers or magazines, print them out from online sources, or take your own photos. Then place your drawn image on top of this background—by drawing directly on the background, by taping or gluing the art in place, or by using the "billboard" technique discussed on the previous pages. See what you can come up with!

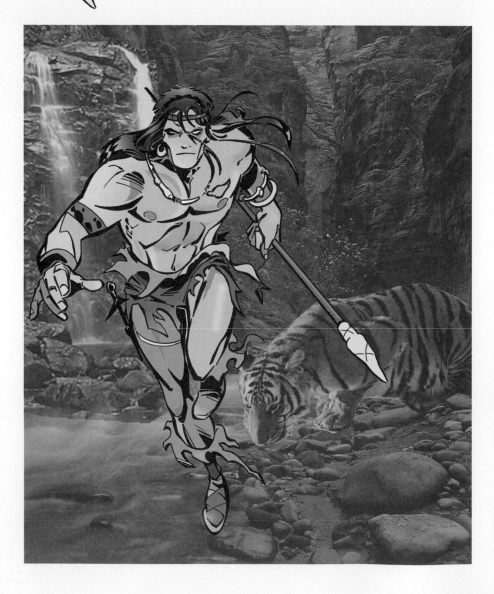

Again, backgrounds not only give extra info but also add a feeling of depth to a drawing. Some objects appear closer, others farther away. You can intensify the effect by overlapping objects and then using a heavier line around the foreground figure—or even putting the closer figure in silhouette. The added emphasis on the closer figure brings it into clearer, sharper focus and underscores its threatening quality and its importance in the composition.

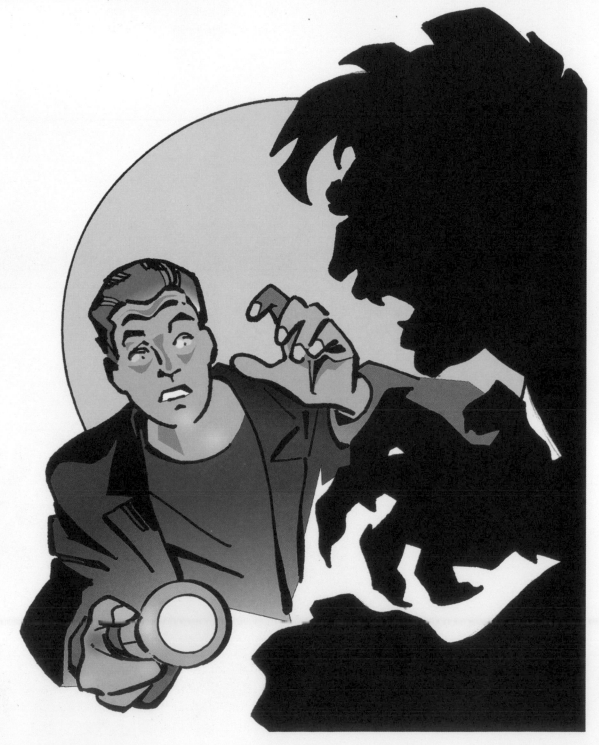

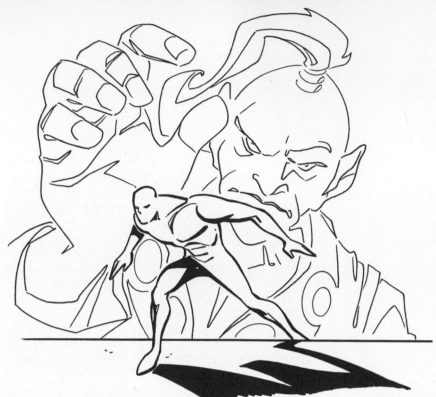

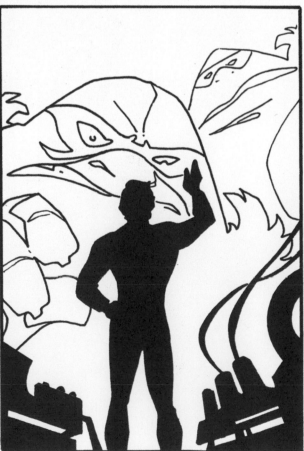

In these examples, we're not just overlapping the background with the foreground figures. We're also playing around with their respective sizes. Because of that, we know that the tiny titans in the foreground of these pictures really *are* tiny—or that their enemies are huge! The foreground figures also seem closer to us because of the heavier outline and the silhouette. These techniques make the foreground figures seem closer and bolder and make the figures in the background seem less important.

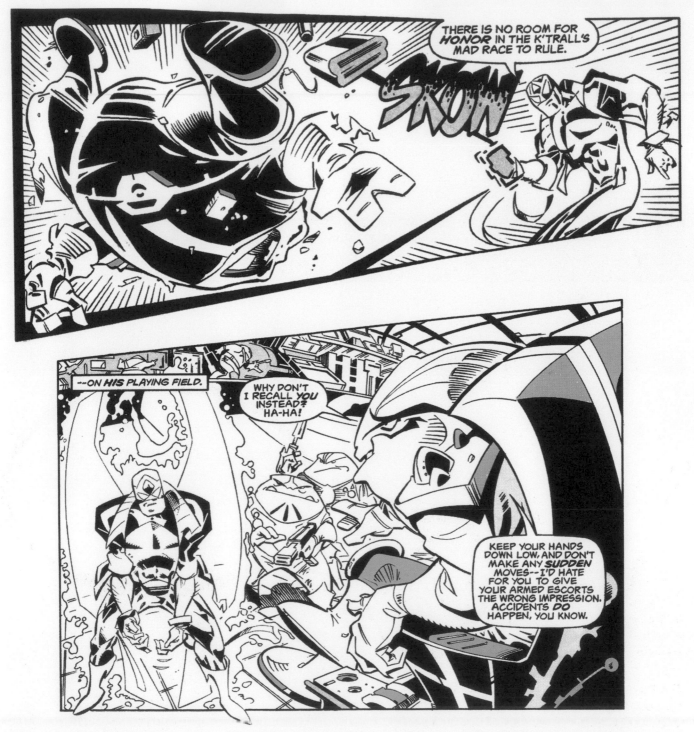

Once again, using darker lines and bolder, black shapes on figures in the foreground brings them even closer to the viewer.

SPECIAL BACKGROUND ELEMENTS

There are lots of other ways to create effective backgrounds, including using shadows and frames, heavily blacked-in areas, radiating lines, and lines indicating motion. These cool **composition elements** can really pull the viewer's attention right to your main subject.

Other kinds of background elements can also lead the eye to the main focus of your drawing. Some you may never have thought of before!

One great background technique is to add shadows and frames that surround your main subject.

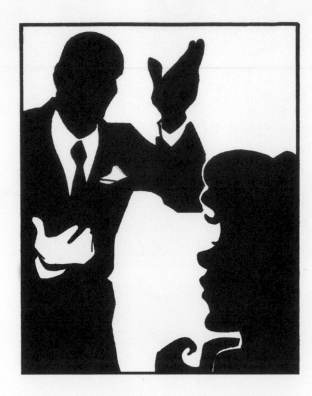

Talk about bold! All we see—and all we *need* to see—in this serious, somber, silhouetted, and shadowed setting are the forms of the man and woman, as well a few **details,** such as the man's hands and the visual **suggestion** of the business suit he's wearing.

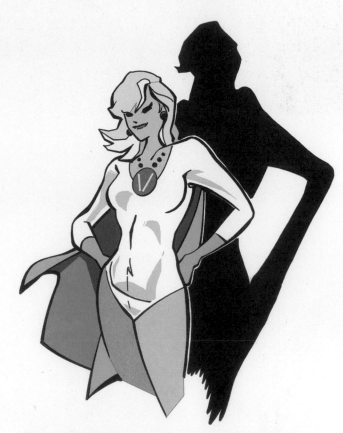

This gal's shadow makes for an interesting background, partly framing her form and adding depth to the image.

And notice how this poor chap's dark form is boxed in by the large, jagged slabs of black that frame him.

You can also use shadows and frames in—you guessed it!—a more abstract way. Both of these, er, gentlemen are defined by **negative space.** That means that the background elements actually create the figure in the foreground. In the drawing above, dark stripes define enough of the character's shape that he doesn't need an outline around him. It's a very dramatic effect!

Notice something odd about this giant gentleman? His entire form is defined *only* by the background. Yes, again we're using negative space. To achieve this kind of effect, draw the outline of your figure in pencil. Then, when you ink in the background, bring all the lines right up to the figure's form. Let the ink dry, erase your original pencil drawing, and you've done it.

In these examples, notice how the heavy black areas separate the figures and create **tension.** By dividing panels into dark and light areas, you create lots of **contrast.**

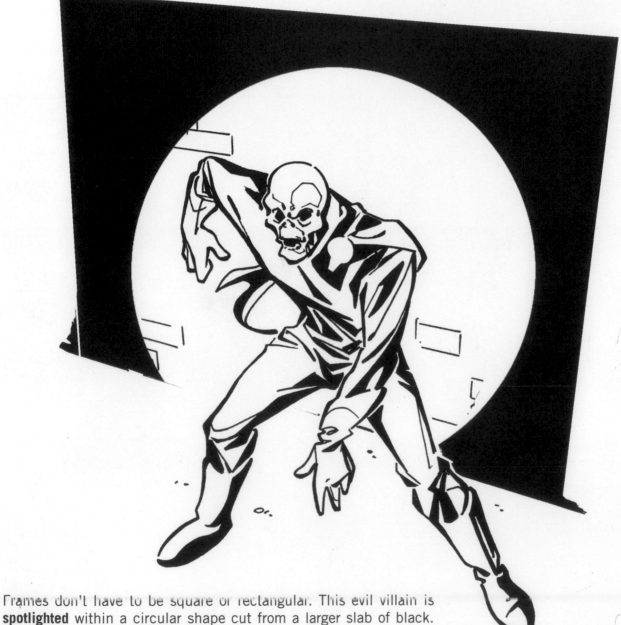

Frames don't have to be square or rectangular. This evil villain is **spotlighted** within a circular shape cut from a larger slab of black. There's no doubt who's the center of attention here!

Sometimes, background elements point to the composition's main focus. Note how the ribs of this hero's cape all point back to him, making this running figure the center of attention.

The same goes for this gent. His figure is positioned right at the center of the radiating arms, making him the main attraction. (If you could call this guy an "attraction"!)

And there are yet other kinds of background elements that you can use to guide the viewer's eye. The blast lines that radiate out from the fist on the left side of this panel lead your eye right back to it!

Here, the background is filed with motion lines, all emphasizing the **direction** the object was thrown in, *away* from the main figure!

The network of lines in this background design points to—and leads your eye to—the character on the right.

And here, the **perspective** on all that fancy space machinery leads us directly to the figure being attacked.

Remember what we said, earlier, about body language? Well, body language can play a role in background design, too. Here, the attacking brute's arms form a sweeping curve, accenting the left-to-right direction of his punch.

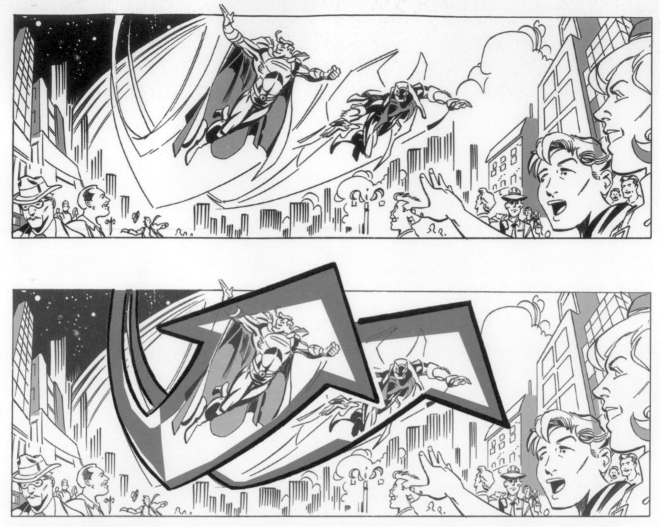

This panel's background contains motion lines—also called **speed lines**—flowing behind the flying characters. Because these lines curve, they accent the way the characters are swooping in from the sky above the city.

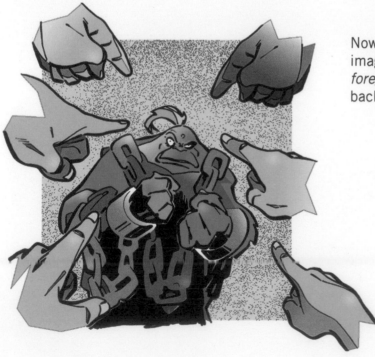

Now, just for a change of pace, have a look at this image. Here, some (very obvious) elements in the *foreground* point us to the bound creature in the background. Talk about leading the eye!

I'll clam up for now. But can you tell, from the background elements in each of these images, what the focal point of each panel is?

TEXTURE, PATTERN, AND SHADING

Another easy, exciting way of adding **detail** and **information** to your art is through the use of texture. Texture gives the viewer an idea of the surface **patterns** of an object or the "feel" of an object.

Texture can make a drawing seem much more realistic—adding form and weight to what you draw!

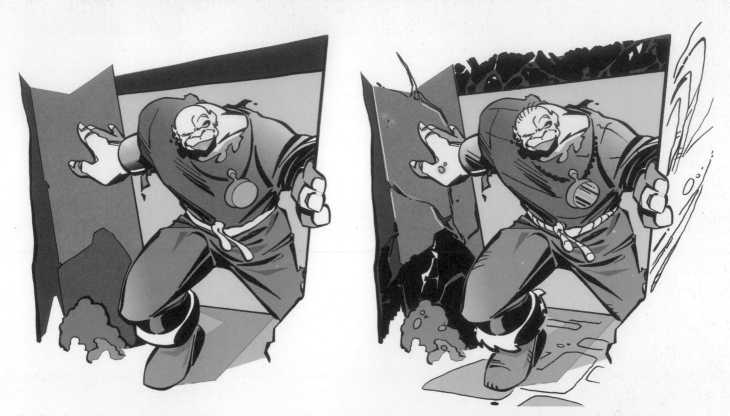

Notice here how just the addition of simple lines and dots to the basic drawing gives a lot of extra information to the viewer—conveying the details of the character's hair, the necklace's beads, the medallion's shininess, the stone walls' and floor's texture, and even the leafiness of the plant at the lower left.

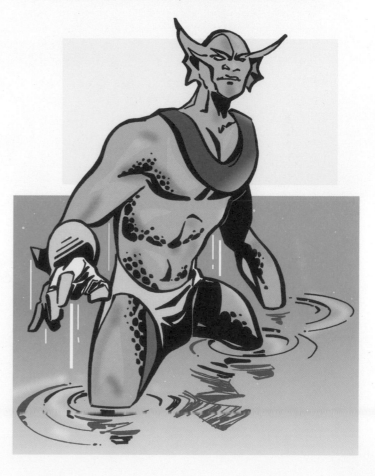

Dots are used to represent surface texture in these examples. The dots are grouped close together for heavier shading, farther apart to create more lightly shaded areas. It's a simple but effective way of conveying form.

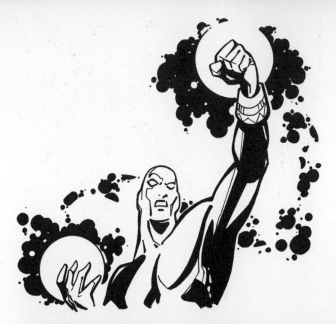

Here, the dots grouped around the figure and his hands help define shapes around his form and give a "cosmic crackle" to his powerful punch.

Remember negative space? This example uses background dots to create the outline of the foreground figure. That's a lot more interesting than a plain old outline.

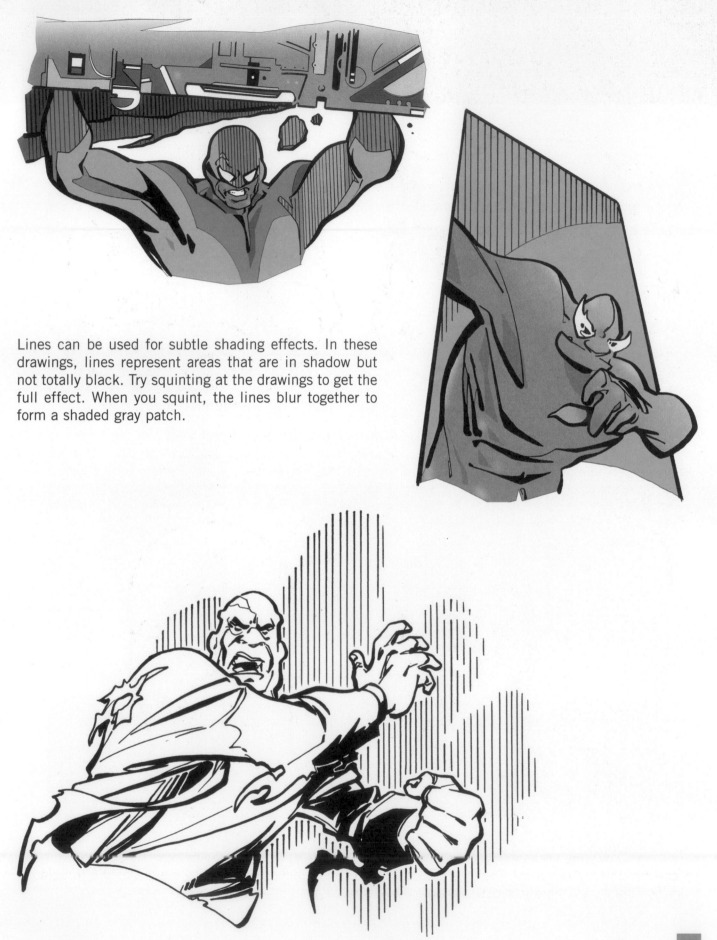

Lines can be used for subtle shading effects. In these drawings, lines represent areas that are in shadow but not totally black. Try squinting at the drawings to get the full effect. When you squint, the lines blur together to form a shaded gray patch.

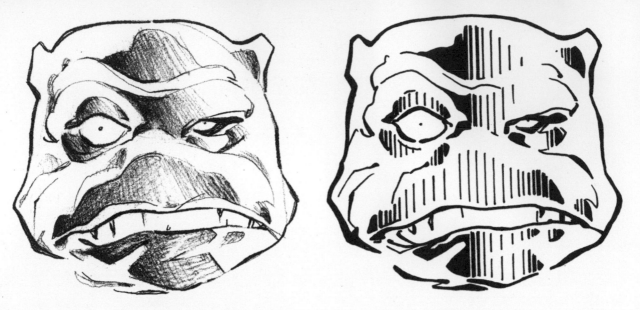

If you're using pencil, you can represent shaded areas with a lighter or darker solid gray tone. But if you're using ink, you've got to use lines to convey the idea. Here, the pencil drawing on the left is shaded with gray tones. The image on the right uses parallel lines to get the effect in ink. Bringing the parallel lines closer together makes the shaded area even darker.

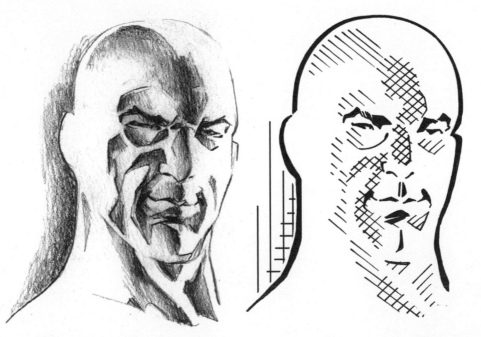

Here's another example of a pencil drawing versus an ink drawing. Notice how some of the darker areas in the ink drawing at right are created by crossing lines—a technique called **crosshatching.** Here, the darker patches are created by crossing lines. Try squinting at these examples.

It's important that parallel lines be truly parallel. Consider using a **drafting triangle**—placed flush against a **T-square** or the lip of a drafting table—to help keep all your lines straight. And you can avoid smearing your lines by working from left to right if you're right-handed or right to left if you're left-handed.

Here are two more illustrations in which lines create subtle shading effects. Look at how both of these images use carefully placed parallel lines to create a really cool design!

There are many ways to use lines creatively. Look, for example, at how just a few lines and linear rectangular shapes emphasize the impact of this guy's punch. Notice, too, the crosshatched lines used for shading on his face and the white lines radiating from his fist, which break up the large black areas.

Here, again, lines are pushed closer together for darker effects and pulled farther apart for lighter areas. They also frame our hero nicely.

This guy is appearing in a sudden puff of smoke. Since we can see his lower body only very dimly through the smoke, lines are used to represent the gray, hazy area near the bottom of the drawing.

The lines on this demon's form suggest shading seen through a field of fire. You can still perceive the form of his body beneath the flames.

Here's a fleeing figure—maybe an escaped convict on the lam from the law. Since we see him dimly in the distance through the fog, his hazy, gray form is defined only by lines.

And here's our frequent flyer again. Note how the lines that show the shading in the clouds are angled so that they not only point to him but also indicate the direction of his flight.

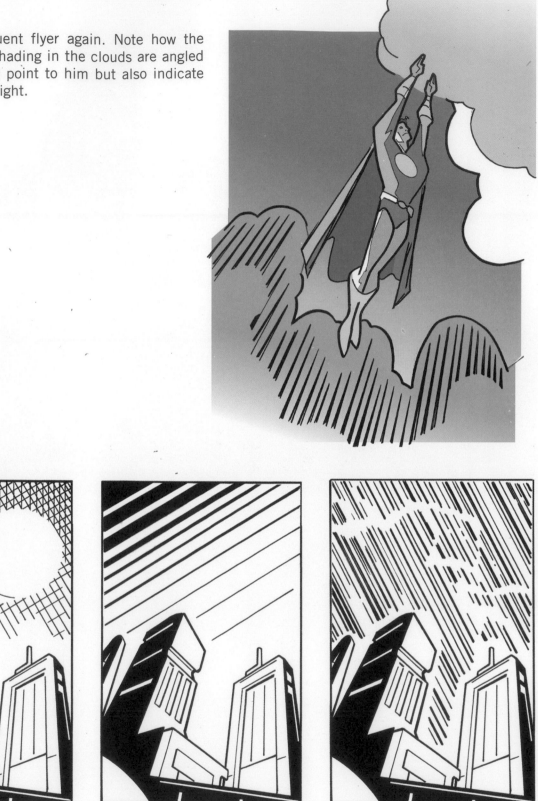

Now, let's kick things up a notch. In this example, we see three different ways of depicting the sky over a city. The panel on the left uses crosshatched lines; the panel in the middle, parallel lines of differing weights. And the differing thicknesses of the lines in the panel at the right show a stormy, rainy sky—with the breaks in the lines suggesting flashes of lightning.

The lines used for shading in the background of this image create a blurry **field of motion** behind the foreground elements and help define the direction of the meteor shower.

Here, groupings of **feathered** lines create a misty, disorienting effect behind the super-guy! The effect is vague and mysterious, with a whirling, smoky feel.

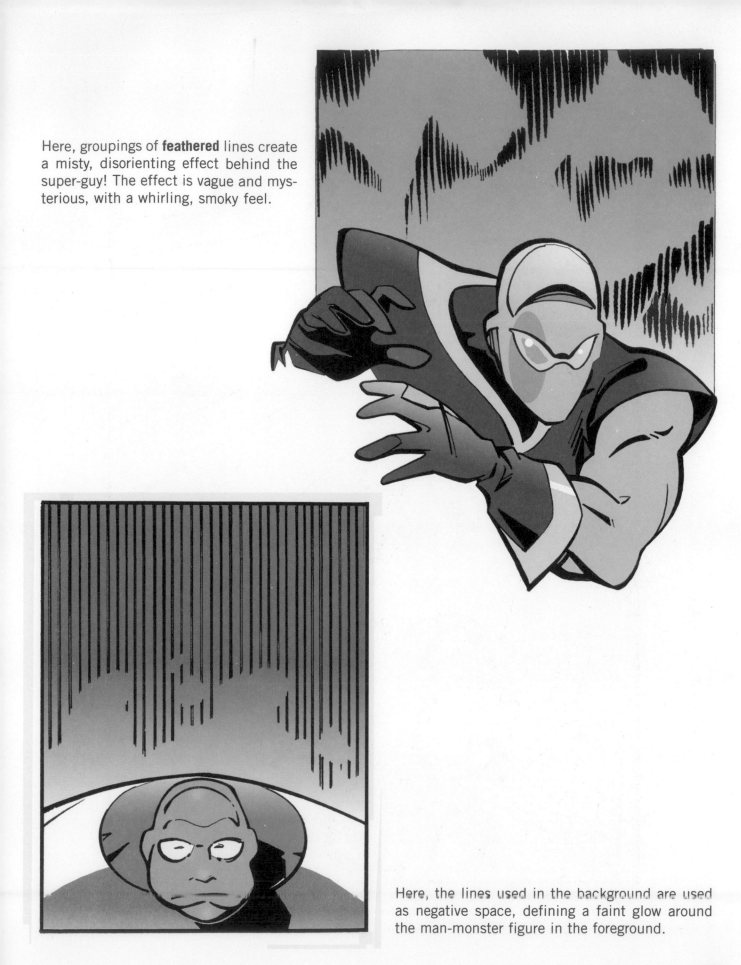

Here, the lines used in the background are used as negative space, defining a faint glow around the man-monster figure in the foreground.

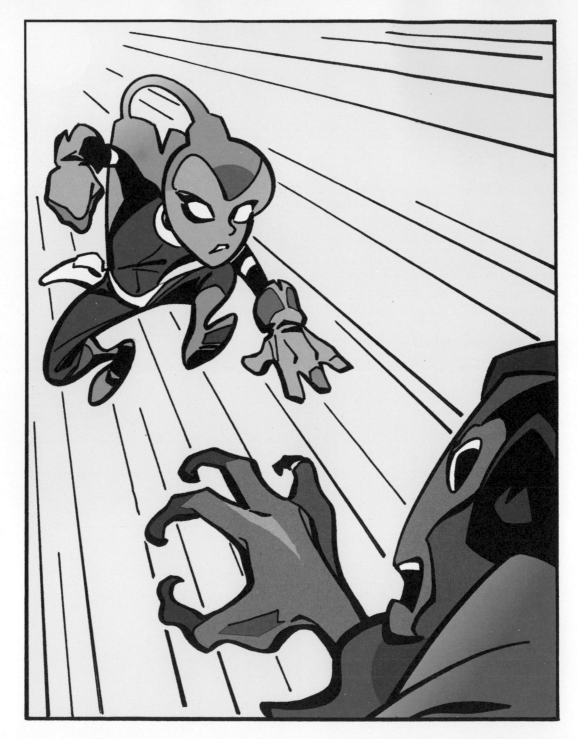

The lines in this drawing aren't just background decoration. They also accent the speed and direction of the leaping munchkin. Look out!

Use simple lines to give objects a shiny, glossy look.

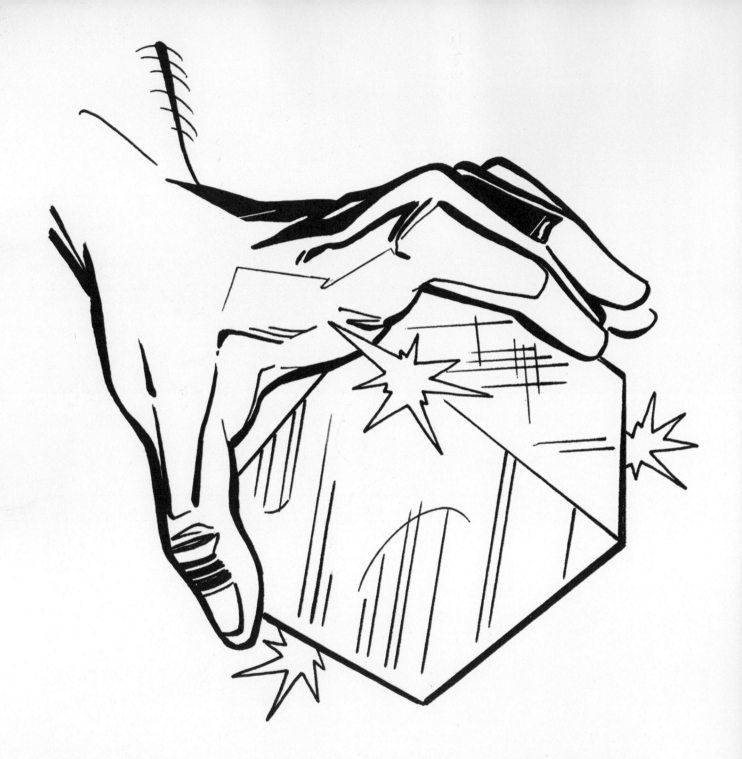

There's almost no end to the kinds of effects that simple lines can achieve! Here, the parallel, cross-hatched, and curving lines represent hazy reflections on the glossy surface of the cube.

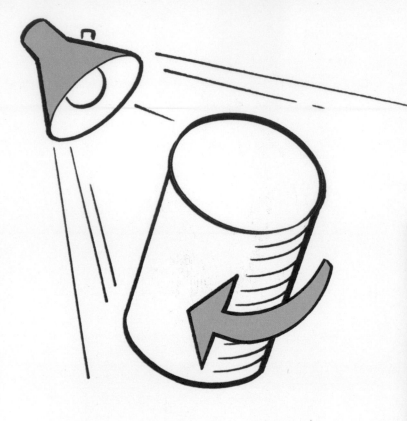

Lines used for shading or texture can also show off the form of a figure or surface. To create a sense of roundness and dimension, use curving lines that seem to wrap around the object being shown.

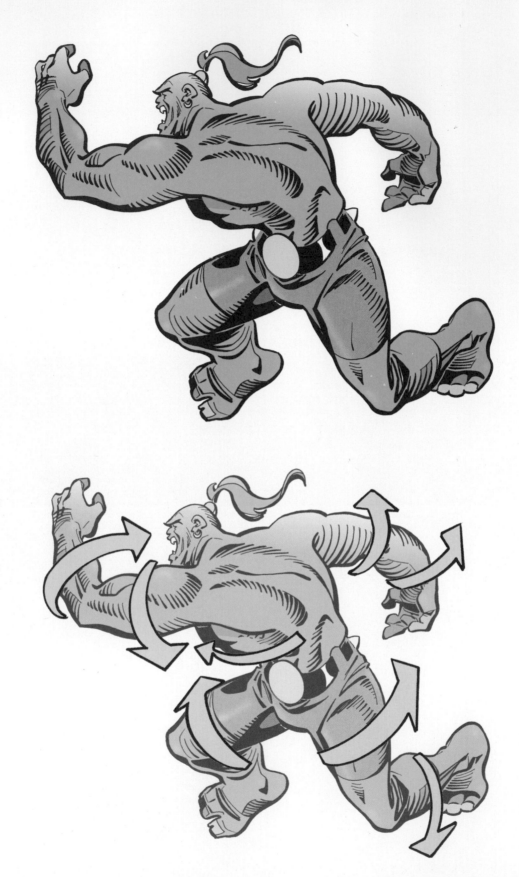

Sure, you could use parallel or crosshatched lines to shade this guy's form, but making the lines curve around his limbs helps define him, giving dimension and roundness to his body.

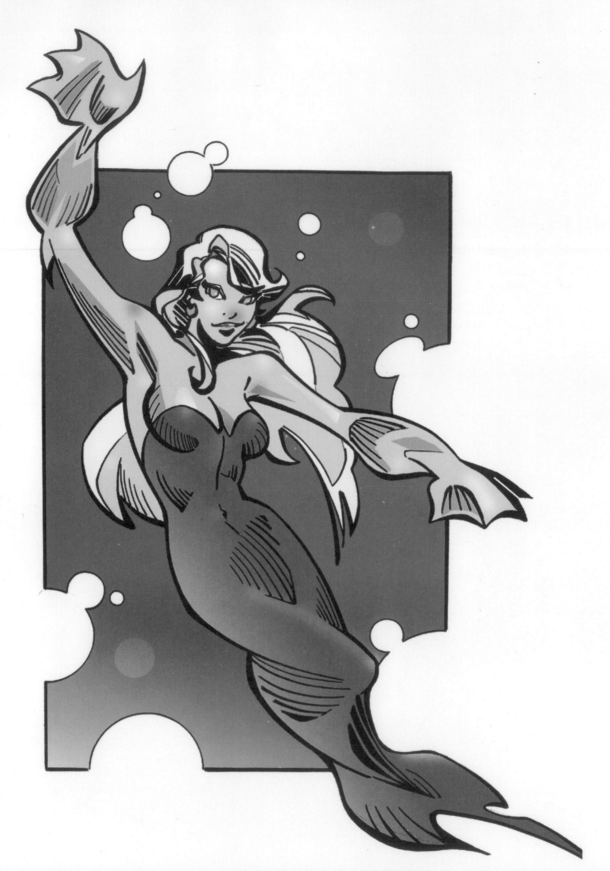

On a more subtle level, notice how the lines used to shade this mermaid flow over the curves of her body, giving us a more elegant sense of form than the lines on the savage opposite. This is one more method for keeping your drawings from seeming flat and dull.

Ever heard of the "splatter" technique? No, I'm not talking about gory horror movies, but a cool way to apply dots—*lots and lots* of dots—to a drawing to create different kinds of patterns and effects.

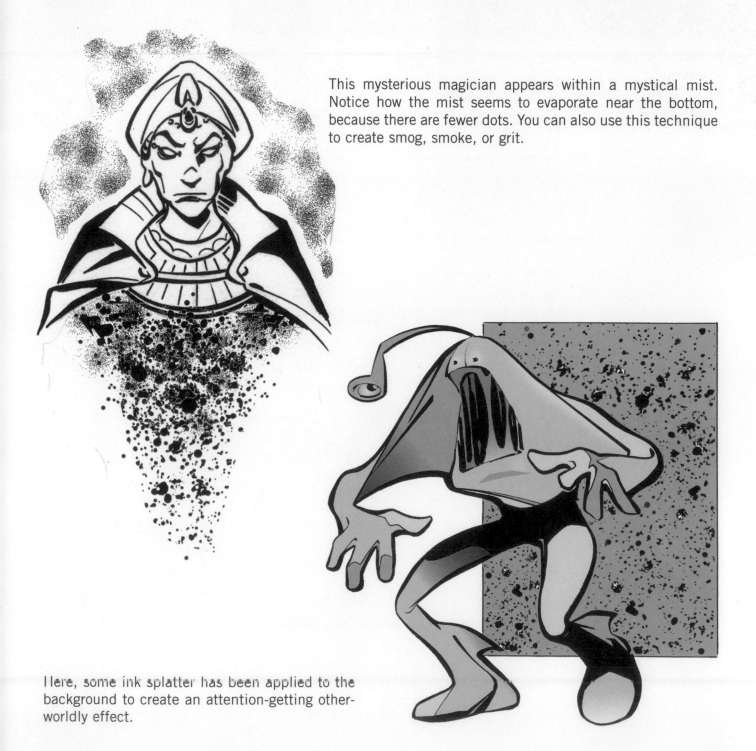

This mysterious magician appears within a mystical mist. Notice how the mist seems to evaporate near the bottom, because there are fewer dots. You can also use this technique to create smog, smoke, or grit.

Here, some ink splatter has been applied to the background to create an attention-getting other-worldly effect.

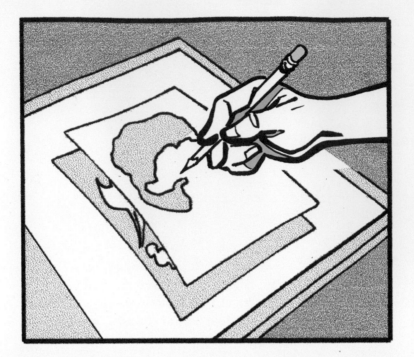

Want to give splattering a try? Here's what you need to do. First, lightly tape your drawing to light box (or to a window during the daytime). Place another piece of paper of the same size over your drawing, lining up the edges. Because there's a light source behind your drawing, you'll be able to see it through the paper on top. Now, lightly **outline** the shape of the area in which you want the splatter effect to appear.

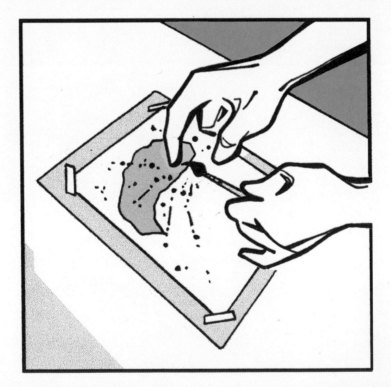

Next, after removing the materials from the window or light box, cut out that outlined area, creating a "window" for the splattered ink. Tape this **mask** over your drawing, making sure everything is secure. Then load a paintbrush up with some india ink or watercolor paint, hold the brush about seven inches above your drawing, and carefully flick the bristles! Experiment with moving the brush around, making the splattering heavier in some areas and lighter in others.

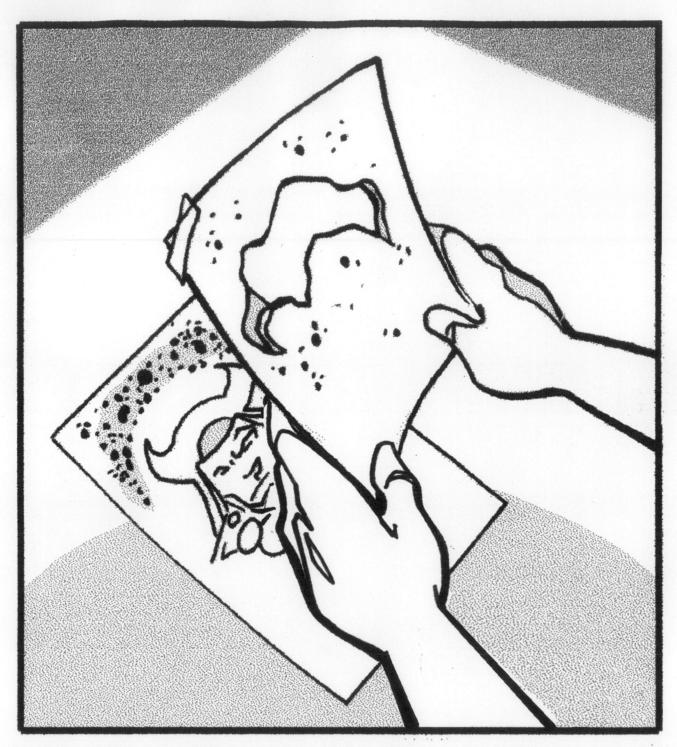

After the ink has fully dried, carefully remove the mask and take a look. The splatter effect should appear only where the open window of the mask allowed the ink to go through.

TIP: Before trying this on a drawing, you may first want to experiment on a blank piece of paper. Also, be sure to take precautions so that the ink doesn't splatter where you don't want it to! Place some scrap paper or newspaper around and under your art when splattering.

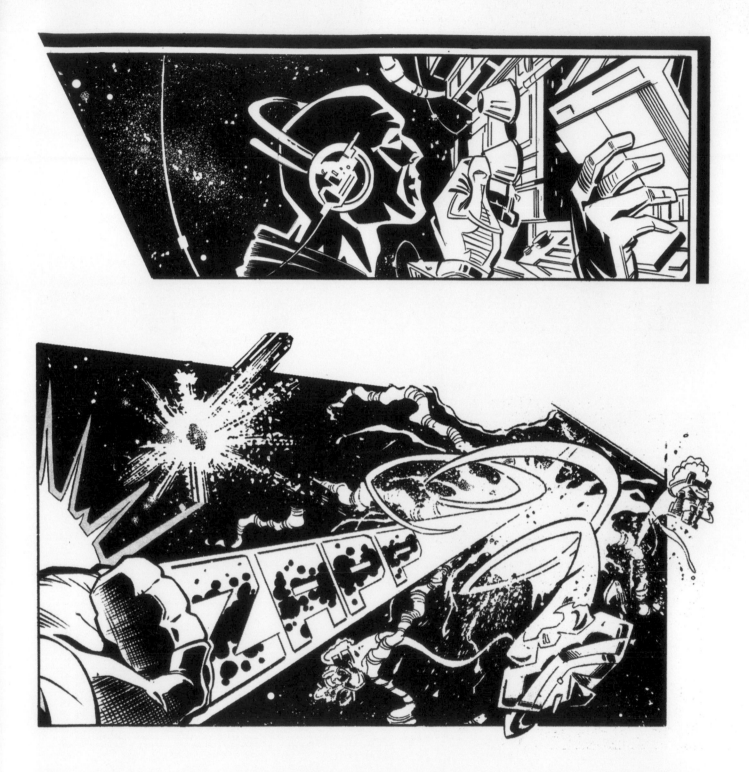

These examples also use the splatter technique, but they're different from the others because they use white paint splattered onto a black background, in a reverse of the usual technique. The white-on-black technique is great for creating outer-space backgrounds, including terrific-looking stars and galaxies!

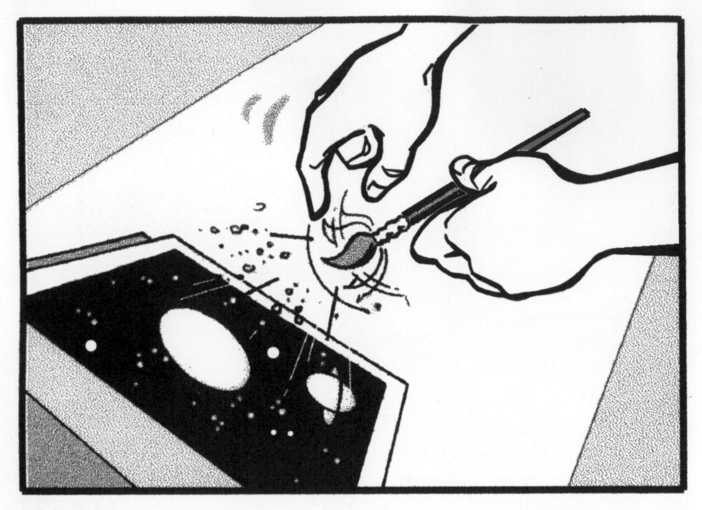

To get the white-on-black splattering effect, make sure that the area you want to splatter is completely filled in with black. Then follow the same steps—but use an opaque white paint instead of black ink. (White acrylic paint thinned down a bit with water works fine.) As you did with the standard black-on-white technique, you just flick the paint onto the area you want splattered.

TIP: You can also use an old toothbrush to get this effect. Hold the brush about four inches above the surface of your art, then flick the bristles or tap the toothbrush's handle with your fingers so that the white flecks land in the cut-out area. The more white flecks you apply, the brighter the area!

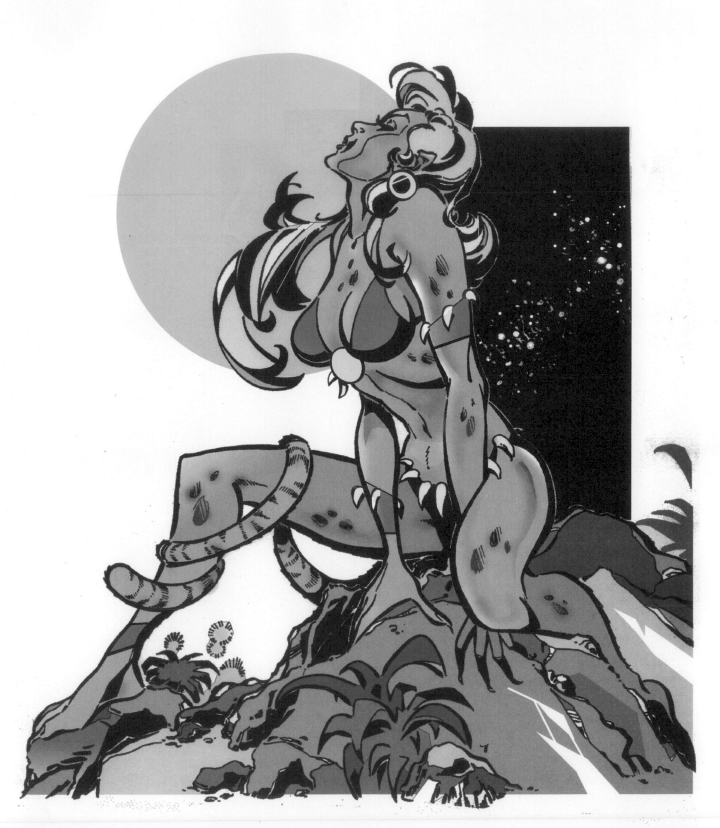

This lovely creature has a star-splattered background that lets us know it's nighttime and adds a bit of mystery, as well. She must be howling at the full moon!

Another way to create exciting and unusual textural effects for your drawings is by doing pencil rubbings.

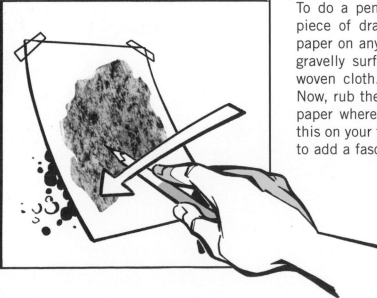

To do a pencil rubbing, grab a rather thin, lightweight piece of drawing paper or copier paper and place the paper on any textured surface—for example, tree bark, a gravelly surface, a textured wall, or a piece of roughly woven cloth. Make sure your pencil is well sharpened. Now, rub the *side* of the pencil lead onto the area of the paper where you'd like the textured area to appear. Try this on your figures, on backgrounds—any place you want to add a fascinating textural element to your drawing.

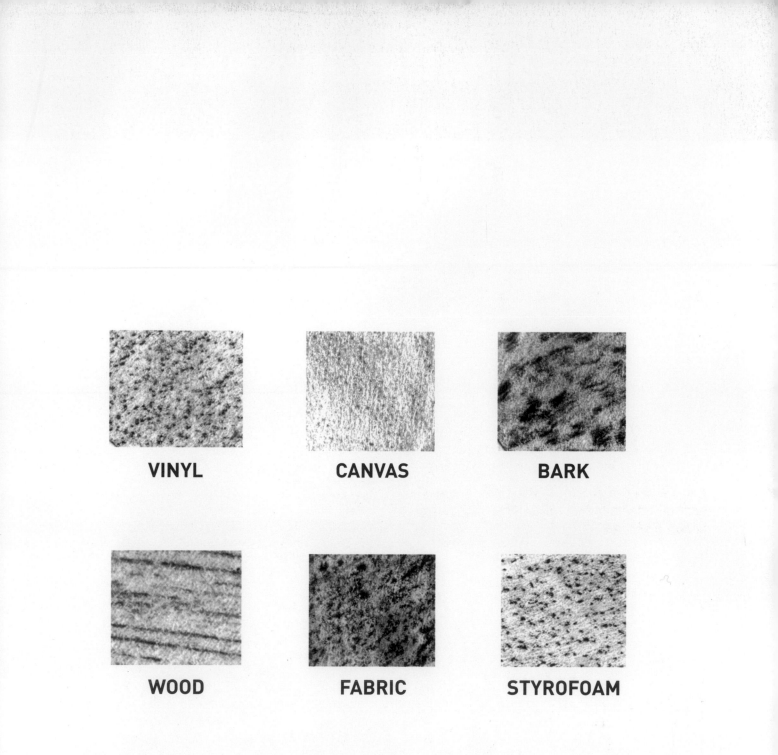

VINYL **CANVAS** **BARK**

WOOD **FABRIC** **STYROFOAM**

Here are some samples of pencil rubbings done on six differently textured materials.

Here's another great effect—one that's a bit easier to accomplish than the ink-splatter technique! Stamping can be done with an old sponge, a piece of textured cloth, or even a crumpled piece of paper.

Here, stamping was used to create the dark, lava-like background.

The smoky fringes of the flames in the background of this drawing were also created by stamping.

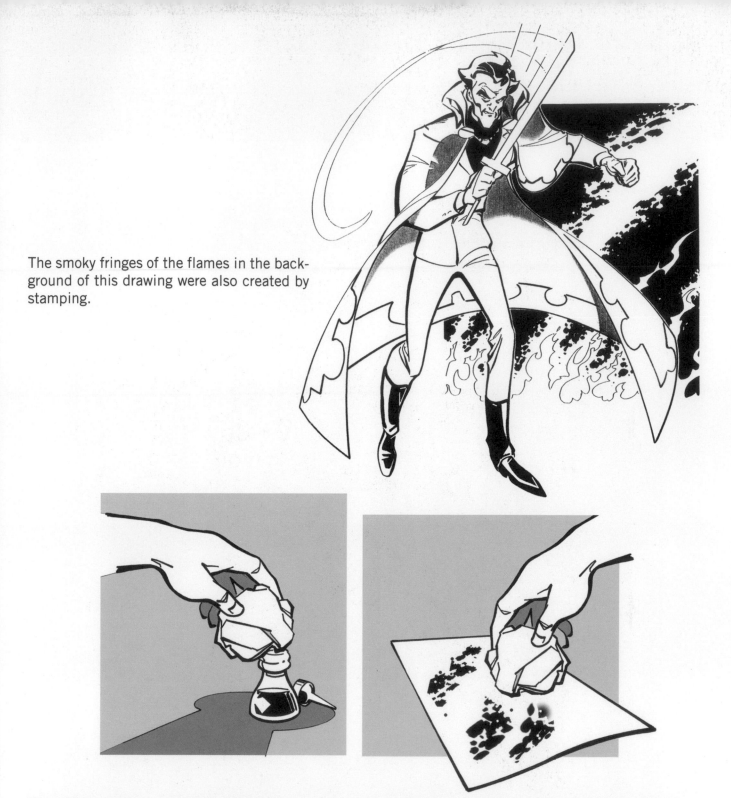

Ready to try? Again, start by cutting out a mask to protect the area you *don't* want the effect to appear in. Then take your stamping material—like the crumpled paper shown here—and lightly dab it in ink or paint. Now, gently press the inked material onto those places in your drawing where you'd like the effect to appear.

TIP: Try using more or less ink—as well as a variety of stamping materials—to get different effects. Remember to protect your work area!

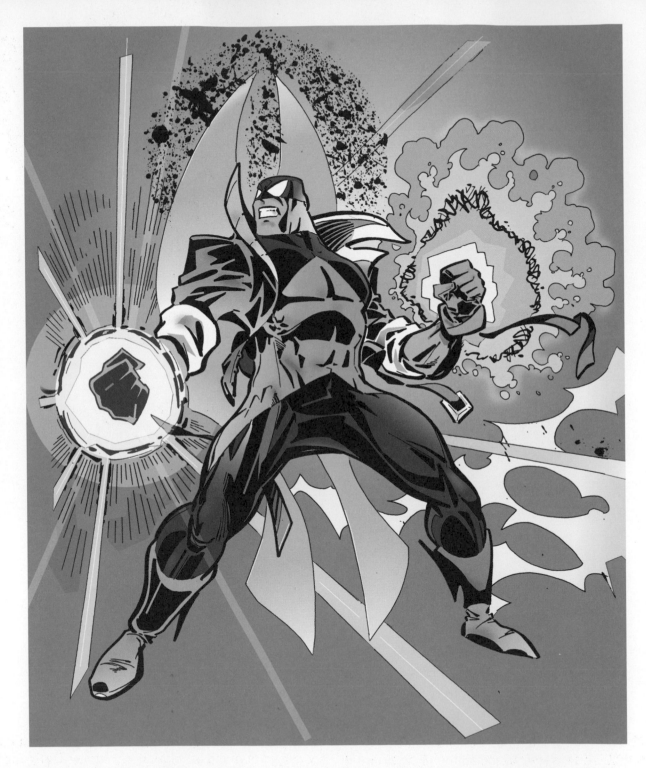

Talk about special effects! This illustration uses stamping as well as splattering and other techniques.

**INK ON
WET SURFACE**

**INK ON
DRY SURFACE**

**INK ON WET,
ROUGH SURFACE**

**STAMPING ON
WET SURFACE**

All kinds of everyday materials and things (cellophane, aluminum foil, old wallpaper samples, your fingers and hands) can be turned into tools for your art. Try using stamping or rubbing techniques using these and other materials. And always remember to stay neat and protect your work area!

GLOWS
AND BURSTS

Surrounding any object—a fist, a weapon, even an entire figure—with a fantastic glowing effect can really show off its power—or simply tell the viewer that something interesting has just happened or is about to happen.

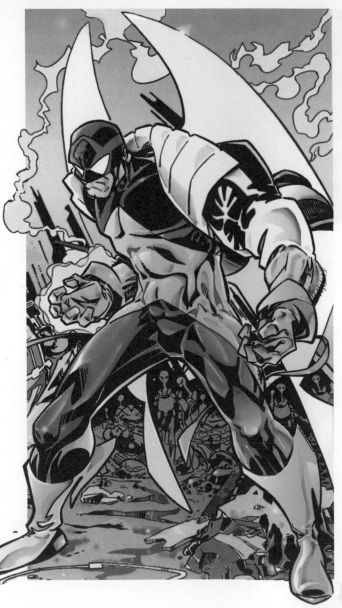

Here, the glow's simple wavy lines show that Geminar has used his power glove to zap some evil aliens. His hand still glows with the power that's just been discharged.

Want to add more super-charged energy to your drawings? Try using some glows and bursts!

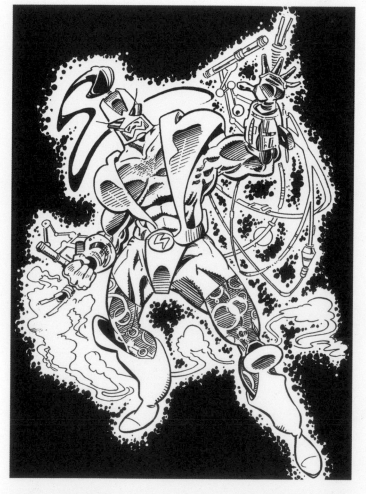

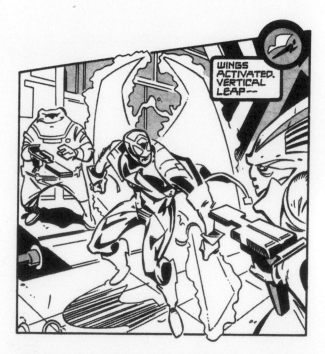

Get a load of this guy! He's just *crackling* with energy and power. That's why the glow surrounding him uses the "cosmic crackle" effect we talked about in the Dots and Lines section on page 70. Stamping around the outline of a glow produces a powerful "hazy around the edges" effect.

And here's another shot of Geminar, with his wings suddenly powering up for a quick leap to freedom. That glow draws your attention to the wings and tells you something exciting is going to occur.

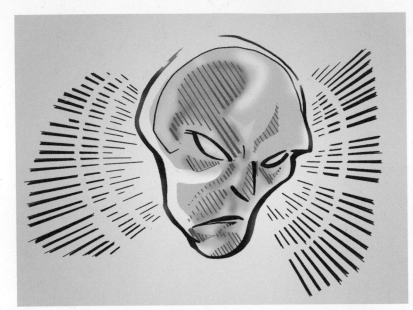

Sometimes a glow can impart a feeling of eeriness or mystery. This floating, skull-like mask has a spooky glow emanating from within—almost like a jack-o'-lantern. The shading on the face is indicated with lighter lines that seem to be obscured by the glow from the skull

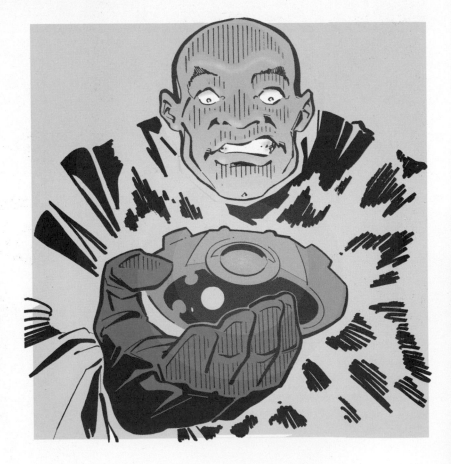

The device this villain is holding is no ordinary weapon. We know that it's unusually powerful—maybe some kind of "ultimate" weapon—because the glow surrounding it just sizzles! Notice how the thick, irregular, jagged lines within the glow keep bringing your eyes back to the major point of interest.

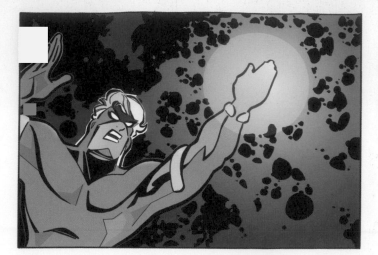

This depiction of a space-surfing hero again uses that "cosmic crackle" effect. Notice how the dots are thinner and sparser up close to the glowing light source but grow thicker and more tightly packed as they move farther away—creating a swirling, spiraling effect.

DEFENSE GAUNTLET BACK ON-LINE AND ACTIVATED.

BZATT!!

The poor guy being zapped in this panel is so engulfed in the glow of the blast that he's been reduced to a murky outline. To achieve this kind of effect, use simple **broken lines** and jagged areas of black to suggest a form overtaken by the light.

This radioactive monster has an eerie glow that's accomplished with two simple wavy lines—one thick, one thin—that wrap around his entire figure. They make it look like his form is throbbing with power. (Without this effect, he'd be a big dumb lug just standing around.)

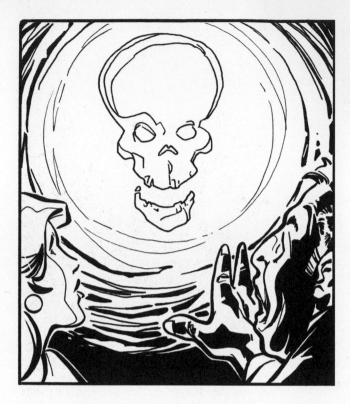

Circular glows can effectively **illuminate** figures and objects—or show light emanating from within them. Note how the lines surrounding this skull grow thinner and sparser the closer we get to the glow and then become thicker where the dark takes over, farther out from the light source.

Here, look at how the **radiating lines** that have been added to the glow point our eyes to the face of this disturbing stranger.

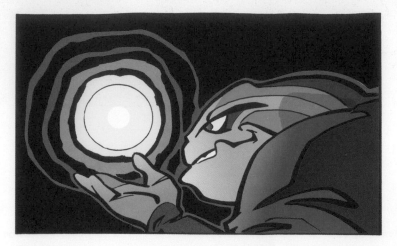

The lines here are odd and wavy, but the same technique is being used: thinner, lighter lines as we move close to the source of light; thicker, darker lines as we move away.

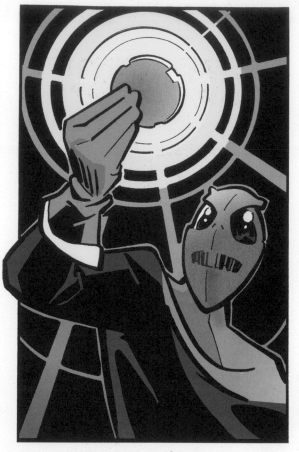

This image is just a bit more complicated. Here, radiating lines emanate from the disk that the masked figure is lifting—and these lines **intersect** and join the circular glow lines. Your eyes are pulled directly toward this uncanny, powerful object!

And this image of a glowing planet uses that same technique. Here, the light dissipates as it moves farther from its source, until it joins the black background.

Bursts indicate powerful blasts of energy. A burst can represent *any* type of energy, whether from fire, heat, radiation, or even a superhero's super powers. Here, the burst shoots from an enemy starship that's blasting our hero (who has his protective shield up, of course).

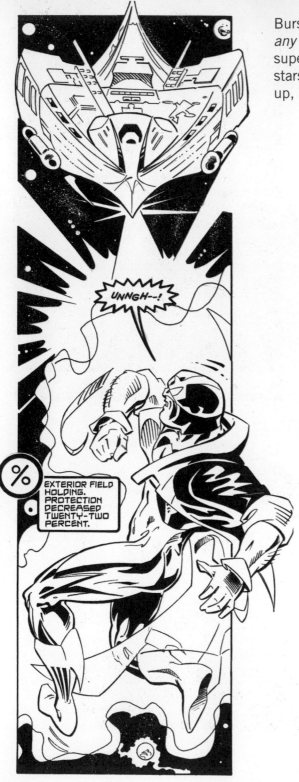

Here, too, the exploding bursts of energy are defined by radiating lines. Note how those lines guide your eye to the face of the hero on the receiving end of the blast.

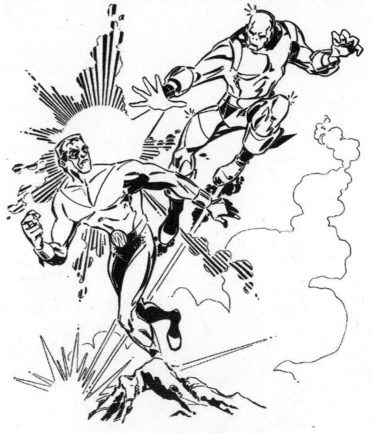

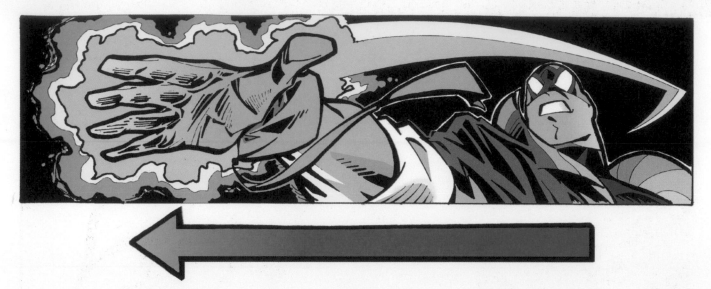

This burst from Geminar's power glove leaves a **trail** that leads your eye from right to left, directly to the glowing hand—the most important part of the drawing.

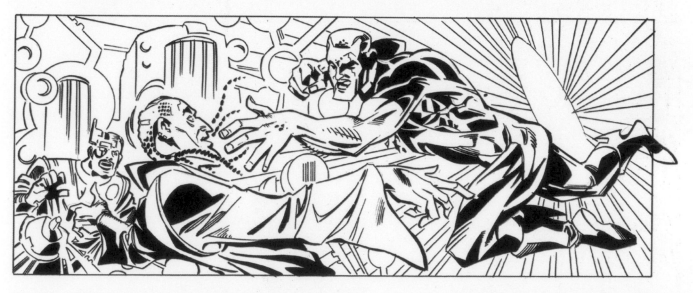

All done with simple radiating lines, this burst represents an energy field through which the hero leaps as he enters another dimension.

Speaking of leading the eye, here are a few more examples of how bursts can be used to direct the viewer's attention to the main subject. This pretty lady looks quite surprised, and the burst pointing to her face is a kind of **cartooning icon** that emphasizes her expression.

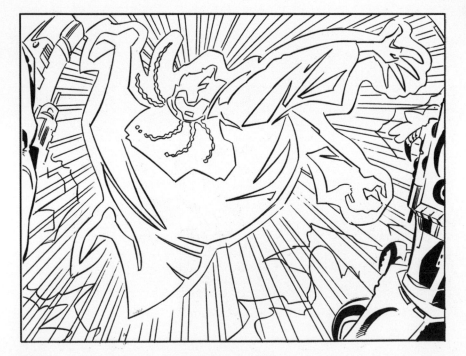

This poor guy twists in defeat as he's zapped by evil forces. Once again, the burst lines bring us right back to him, making his tormented body the focal point of the drawing.

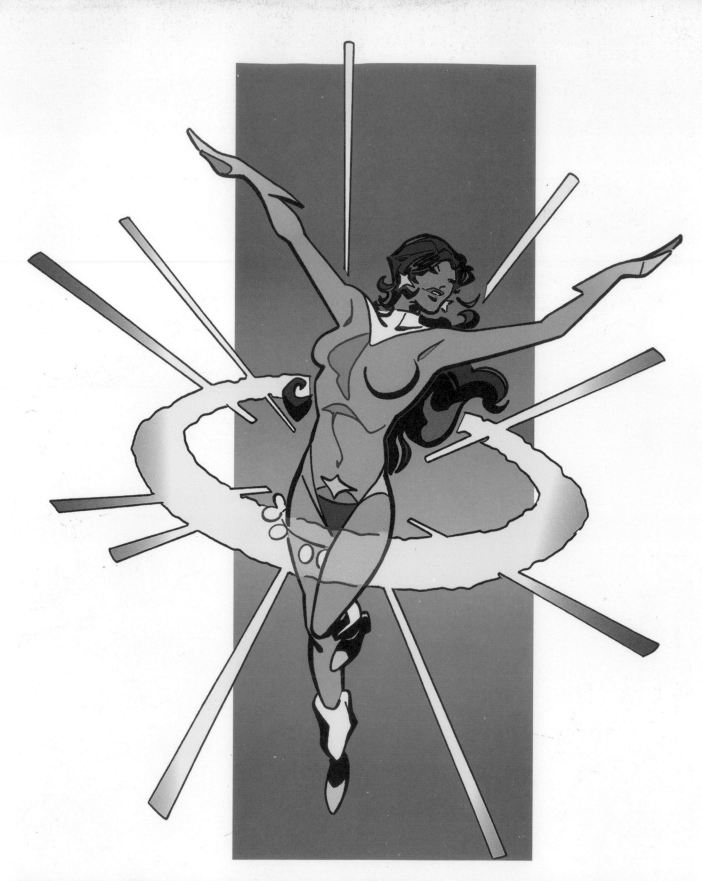

Here's another, different way to depict a power burst. This burst is circular, but it's wrapped horizontally around the lady—almost like a hula hoop! With those radiating lines added, there's no doubt that she is the source of the power.

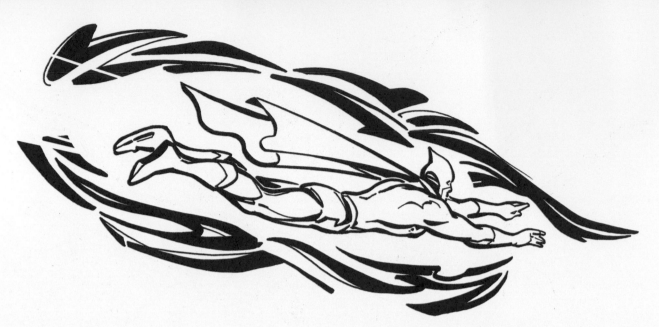

Glows and bursts can indicate things other than sources of light and blasts of energy. The odd, patterned glow/burst around this super-dude shows that he has his own protective field that surrounds him as he flies. The wavy lines indicate the moving, changing energy pattern. The negative space they create seems to form a cocoon around him.

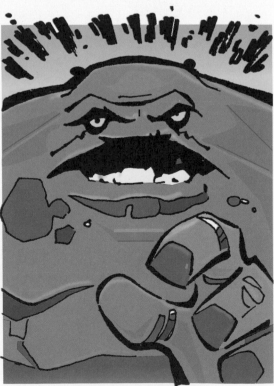

Burst lines can even indicate emotions. What do you think the lines above this guy's head mean? That's he's surprised? Frustrated? Aggressive?

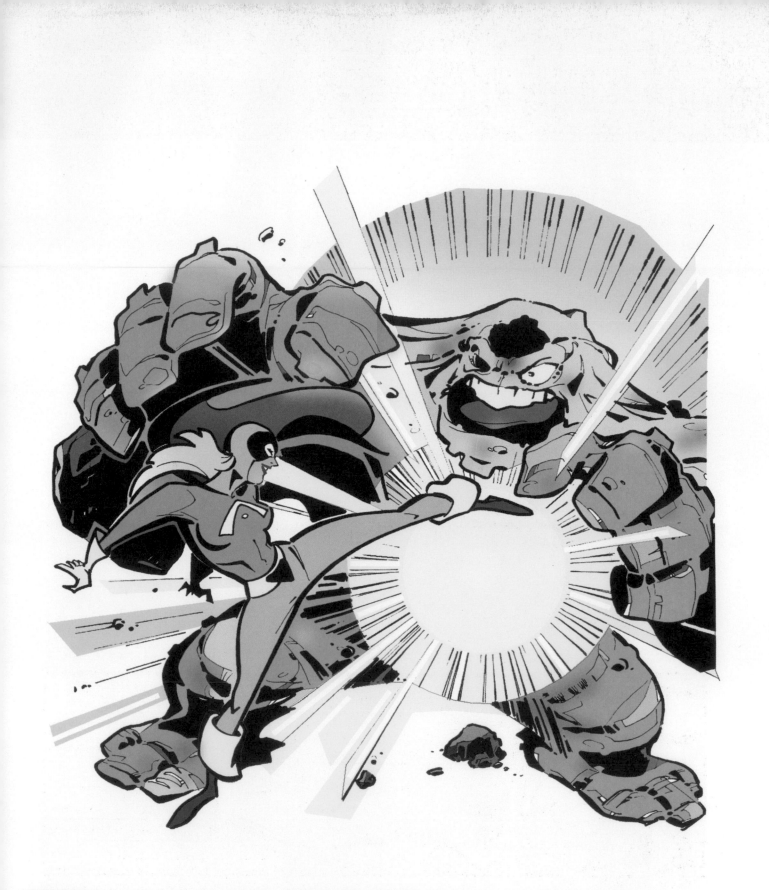

And bursts can indicate a moment of impact. Here, the burst shows where the lady's kick is landing—and that it's having quite an impact on the big blue brute. The supercharged effect is created with lines alone!

SPEED AND MOTION

Lines used in backgrounds and in conjunction with your figures can give a powerful feeling of motion and speed.

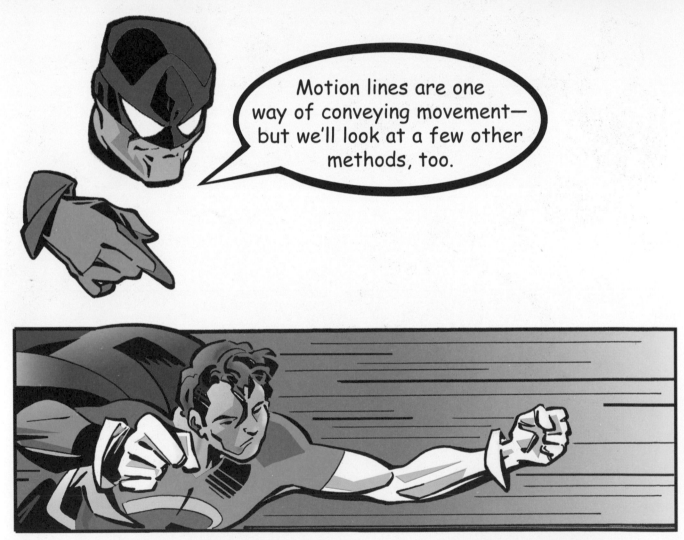

> Motion lines are one way of conveying movement—but we'll look at a few other methods, too.

Take a gander at this flying super-type. You begin to get an idea of side-to-side motion because of his outstretched left arm and because the panel is so strongly **horizontal**—but it's those simple **straight lines** that really convey motion. They make us feel that he's going so fast that the background is only a blur.

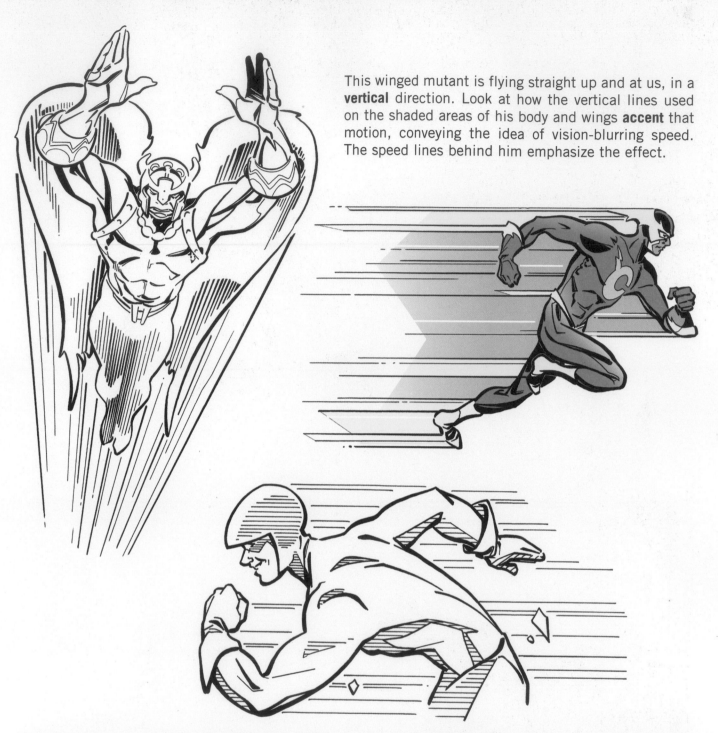

This winged mutant is flying straight up and at us, in a **vertical** direction. Look at how the vertical lines used on the shaded areas of his body and wings **accent** that motion, conveying the idea of vision-blurring speed. The speed lines behind him emphasize the effect.

Here are two super-speedy runners! In the drawing at top, standard, straight speed lines trail behind the runner—but notice how some lines overlap his form, producing a slight blurring effect. Speed lines are likewise used in the drawing below, but here the effect of rapid right-to-left motion is heightened by the horizontal lines used on the shaded areas of his body.

TIP: When drawing running characters, tilt them forward into the direction they're moving. Drawing a perfectly upright figure with motion lines behind him (or her) will not give a real feeling of speed or movement.

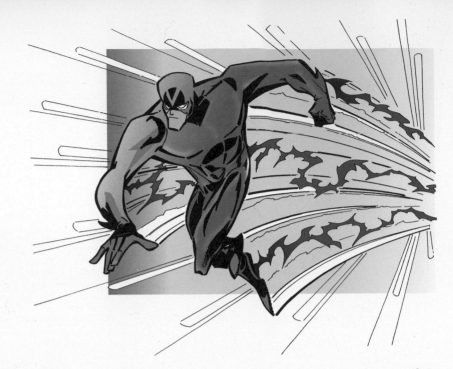

The motion effects behind this cosmic crusader combine directional lines with some cool, jagged **lightning strips** flying from him as he speeds along. The lines make it seems as if he's blasting out of the starting point on the right side of the drawing.

This martial arts master is leaping into a devastating kick. Simple motion lines, all emerging from his starting point, accent his forward thrust.

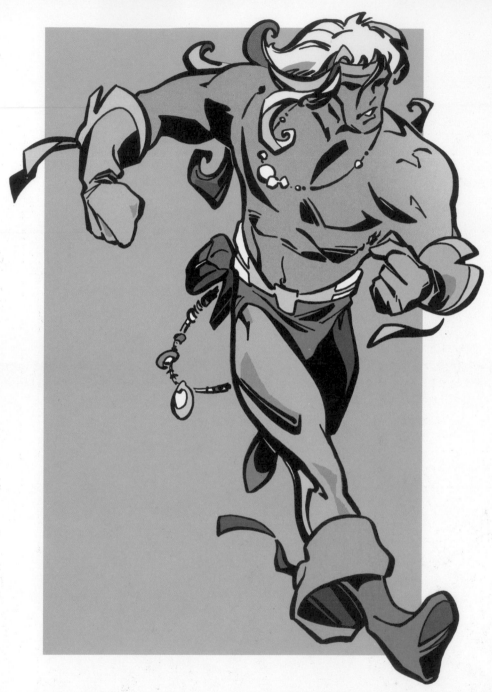

You can tell that this tough guy is running, but where are the speed and motion lines? Well, they're not always needed. In this case, the details of the costume—flowing and whipping behind the runner—are all that's needed to convey the character's left-to-right sprint. His necklace, chains, boot cuffs, tassels, and hair *all* move in a way that tells us his direction and speed. That's one reason so many super-types wear big flowing capes!

We've touched on this subject, but let's take a closer look at how using strongly vertical or horizontal panels can accent the feeling of up-and-down or side-to-side motion.

Sure, these panels could have been designed horizontally, but giving them a vertical orientation really emphasizes the feeling of top-to-bottom movement—and also of **distance.** The reader can almost feel the drop!

On the other hand, giving your drawing a horizontal orientation gives it a strong side-to-side feeling.

Your eyes move right across these slim panels, from left to right.

As you look at this panel, think of a wide-angle movie screen. Sometimes the camera pans across a scene, following the action and directing our eyes to the most important element. Where do *you* want your viewer to look?

WATER, FIRE, AND SMOKE

Water, fire, and smoke effects are some basic elements of action comics. Let's look at a few ways to create them—some more realistic, some more abstract. Use your imagination and have *fun*!

In this illustration, a spaceship explodes from the waves and rockets into the sky. To get the effect, just surround that surface burst (remember bursts?) with a few dark **wave patterns** and have some speed lines flowing behind the ship.

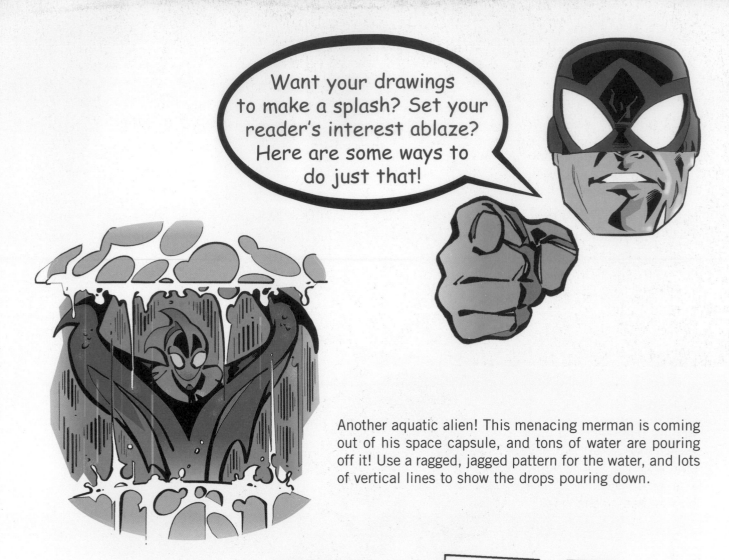

Want your drawings to make a splash? Set your reader's interest ablaze? Here are some ways to do just that!

Another aquatic alien! This menacing merman is coming out of his space capsule, and tons of water are pouring off it! Use a ragged, jagged pattern for the water, and lots of vertical lines to show the drops pouring down.

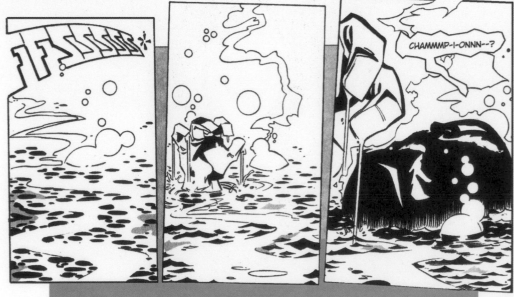

CHAMMMP-I-ONNN--?

In these panels, a monster is emerging from a calm sea. By adding **bubble patterns,** mist, and dark and light patches on the water's surface, you create excitement. (The effect looks kind of like the "cosmic crackle" effect discussed in previous chapters, yes?)

This red-hot firebrand here looks cool—er, hot—because his body is framed by jagged, dancing flames. Because his body is so darkly shaded, we get the impression that the fire's glow is behind him, and the effect is almost that of a silhouette.

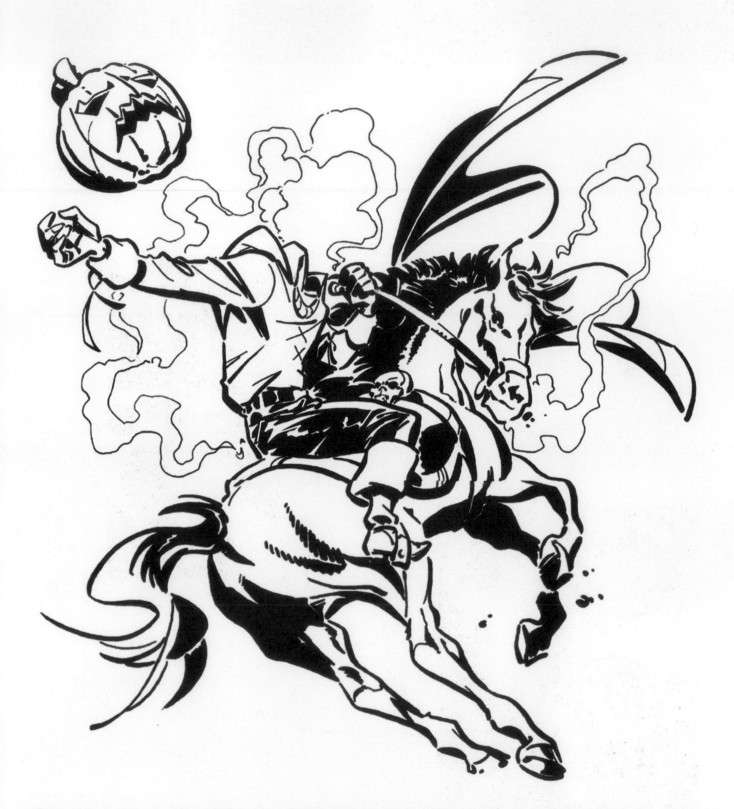

Where there's fire, there's smoke — but sometimes you can create a mysterious effect with smoke alone. In this drawing, the smoke pouring from the headless horseman's neck wraps around and frames the main subject. It keeps your attention focused on the horseman and the horse's head.

This flaming flyer is outlined in "standard" flames, but blobby black shapes have been added around the edges, giving the impression that thick black smoke is pouring from the flame. For an illusion of depth, wrap the smoke tightly around the fire trail, and make the closer black shapes larger than those that are farther away. Looks like this guy is headed right for us!

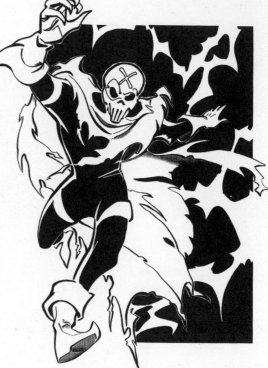

The stuff surrounding this skull-faced villain isn't exactly fire—it looks more like crackling lightning. The quick, jagged shapes in the background add to the dangerous feel of the drawing. (And they also kind of match the torn cape worn by this character.)

This poor guy is caught in some kind of firestorm. He seems totally engulfed in the glow! By suggesting only part of his form and letting it mix with the jagged background shapes, you make him look like he's being swallowed by the flames!

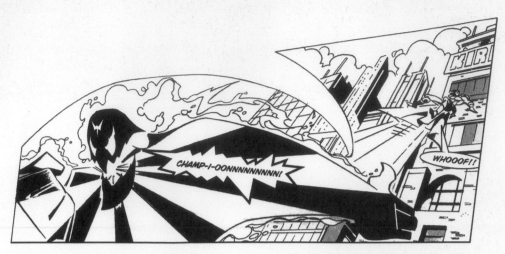

There's a dangerous radioactive mist drifting off this giant fellow! The waves of heat and flame dance and leap like the fires that explode from the surface of the sun. You can get this effect by combining a jagged, torn line with curvy, smoke-like shapes.

Here the smoke is wispier and more ribbon-like. Notice how it stretches back to indicate the direction taken by the flying hero. Like speed lines, the smoke gives a strong sense of movement.

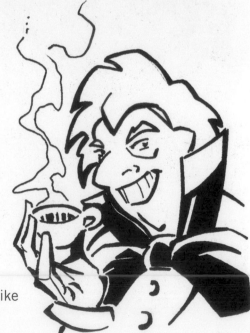

Let's slow things down and have a cup of tea. Use gentle, ribbon-like shapes to create wispy smoke or steam. And relax!

In the real world, you *hear* words and sounds. In the world of comics, you can *see* them, as well! **Typography**—printed text—can make your designs more interesting, informative, and exciting.

Adding words is an obvious—but fun!—way to convey extra information in your drawings.

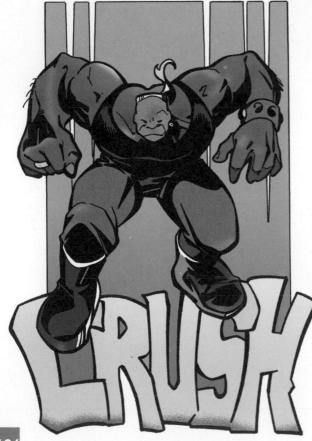

Is this figure interacting with a written **sound effect**? Or is Crush his name? In any case, the design is compelling.

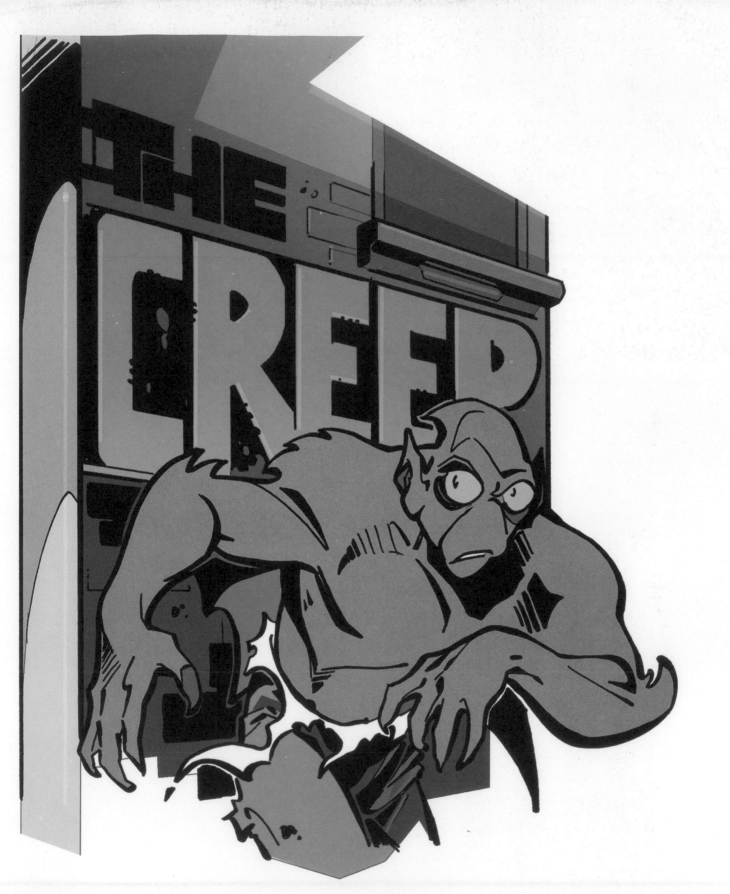

Talk about giving extra info in your drawing! Here, the signage serves as this guy's own personal **logo.** Worked into the perspective of the building, the billboard sure creates a CREEP-y atmosphere!

In this drawing, just a bit of typography—a single **punctuation mark**—creates a feeling of surprise. The exclamation point alone (no words!) is all that's needed to get the hero's shock across to the viewer. How would the message change if we put in a question mark instead?

Of course, you can always rely on standard **word balloons** to communicate the message. Look at how this figure's attitude, which we can read from his body language, is further emphasized by the boldly worded statement! There's no doubt about his intent!

Sometimes you just can't beat the classics! This is probably the most common and best-known use of typography in comic art. But written sound effects can still make a drawing more exciting—and, yes, give the viewer additional information. How else would we know exactly what kind of sound this caped hero's fist makes when it hits the robber's jaw?

In this strange example, our hero, Geminar, is seen through a gun sight. *Geminar* in the crosshairs? It may be an interesting way to present a subject, but who would *dare*?!

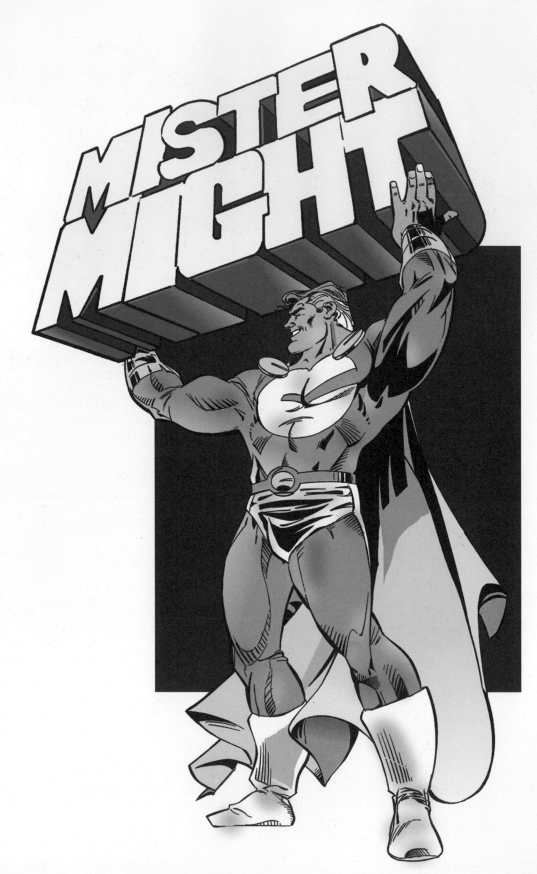

Wow! This hero sure is interacting with his logo! He seems to be using it to demonstrate his might! But it makes a bold statement, as he and his name are worked together into one clever illustration.

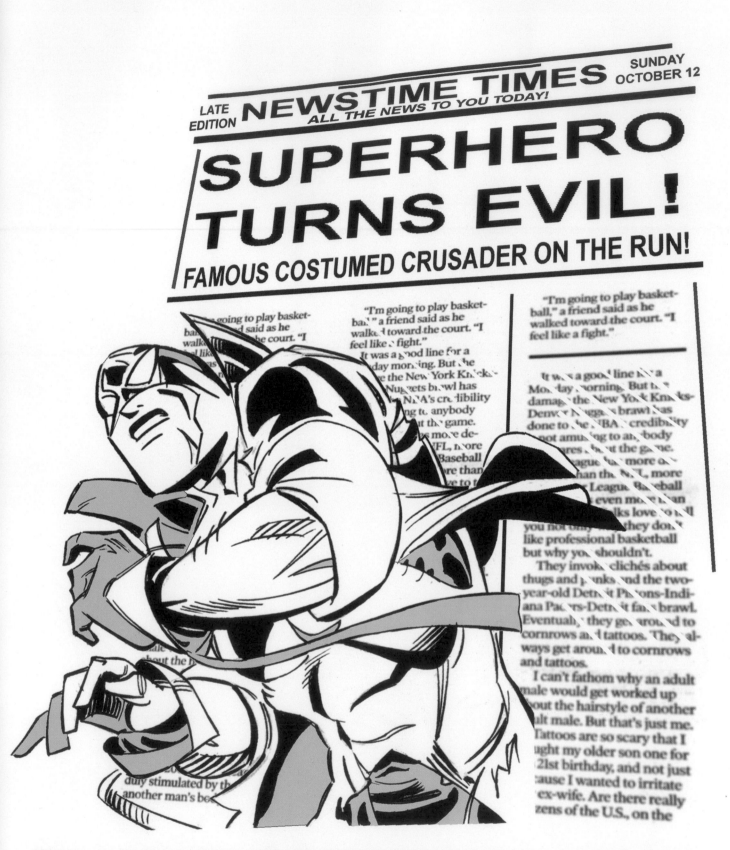

Here we see the **hero on the run** motif, with the figure posed in front of a newspaper's front page to tell you *why* he's on the run. What's going on? Has Geminar been brainwashed? Lots of information is imparted with this dramatic montage technique.

PROBLEM SOLVING

The best way to solve problems with your drawings is to take steps to avoid them in the first place. And the best way of doing that is to keep things simple. Any drawing can make a bold statement if you concentrate on **clarity** and **simplicity.** If you confuse the viewer with too much unneeded detail, the subject, the mood, and the impact can all get lost in the clutter.

Always try to simplify your subject. This not only keeps it clear and exciting for the viewer, but it makes it easier for *you* when starting a drawing. *Always* work with simple shapes—circles, ovals, cylinders, squares, boxes—when laying out your drawing. (*Anything* can be drawn this way.) Forget the difficult, unnecessary details and *keep it* simple!

When there's too much confusing detail, it takes the viewer more time to understand the pose, the attitude, and the situation. And it's even worse when a complex, overworked figure is placed against an overworked background. Everything blends together in one big mess! *Less is more!*

Try squinting your eyes at the two figures here. Notice that the figure on the left takes longer to "read" (that is, understand), while the figure on the right is more direct, bold, and clear. With a great—but simple!—blend of thick and thin linework and solid black shaded areas, he pops off the page.

The same goes for drawing heads and faces. We all know that the human head has thousands of hairs. So should you draw each and every hair? Of course not! *Simplify* the hair, as well as the other facial features—teeth, eyelashes, and so on! It's the very nature of cartooning to give an **impression** of these details, and designs that are simple and easily "readable" achieve maximum impact!

Here are two versions of a hero's head. The one at left has too much detailing and looks overworked. (It also makes the subject look old—too many lines!) By contrast, the version at right seems much more attractive and **iconic**—because it's clean and simple!

To check for problems, try holding your drawing up to a mirror. Sound strange? It's not. Things reflected in a mirror appear reversed, and by "flipping" the drawing in this way, you're giving yourself a fresh, brand-new view of your art. You'll be amazed at how many errors you can spot using this method.

If you have a computer and scanner, scan the drawing into an art software program, and flip the image there. Such programs also allow you to do some corrections on screen.

You can also flip a drawing by using tracing paper. This method is especially good for particularly difficult drawings. To start, begin building your drawing on the tracing paper.

Then, once you're satisfied, turn the paper over to view the reversed, or flipped, version of the artwork. Use this fresh view to look for weak points and problems with proportions and perspective. Now redraw those sections right there, on the back side of the paper.

Then turn the paper over to the original side and erase any errors that you corrected and redrew on the opposite side. You can easily see those corrections through the thin tracing paper.

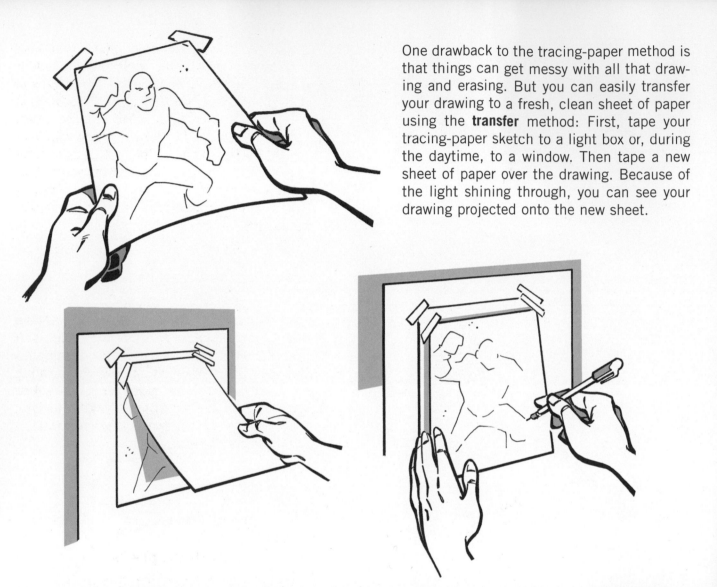

One drawback to the tracing-paper method is that things can get messy with all that drawing and erasing. But you can easily transfer your drawing to a fresh, clean sheet of paper using the **transfer** method: First, tape your tracing-paper sketch to a light box or, during the daytime, to a window. Then tape a new sheet of paper over the drawing. Because of the light shining through, you can see your drawing projected onto the new sheet.

Now, trace the drawing onto the new sheet, keeping only the parts you want to keep and leaving out construction lines and such.

TIP: To check your progress as an artist, *keep all your drawings!* You should save and store every drawing you do. Why? Because saving your work allows you to look back and chart your artistic growth. It also allows you to keep track of the areas where you most need improvement. You can map the weak points you still need to work on while feeling good about how far you've come! Make sure to store your art—finished or in progress—away from pets, small children, eating areas, and direct sunlight!

If you're right-handed, train yourself to work from left to right. (Do the opposite if you're left-handed.) Smudging and smearing mostly result from resting your hand directly on the drawing or dragging it through penciled or inked areas. Start you drawings by working lightly with your pencil. Darken things up (by bearing down a bit more with the pencil) only later, as you redraw and define the lines you want to keep! Keeping your sketchy construction lines light also makes them easier to erase.

Try to keep your hands as clean as possible when handling paper and drawing. If you still have problems with smearing and smudges and you just can't keep that hand from resting on top of the drawing, place a clean sheet of **scrap paper** under your drawing hand, making sure it always stays between your hand and the drawing paper's surface.

If you have problems with keeping your drawings neat and tidy, try these methods.

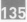

Just because you can draw well doesn't mean you can draw *anything*. You may get assignments that require you to draw a specific object, location, animal, or pose, and you may find yourself scratching your head about how to begin. This is where reference images come in handy.

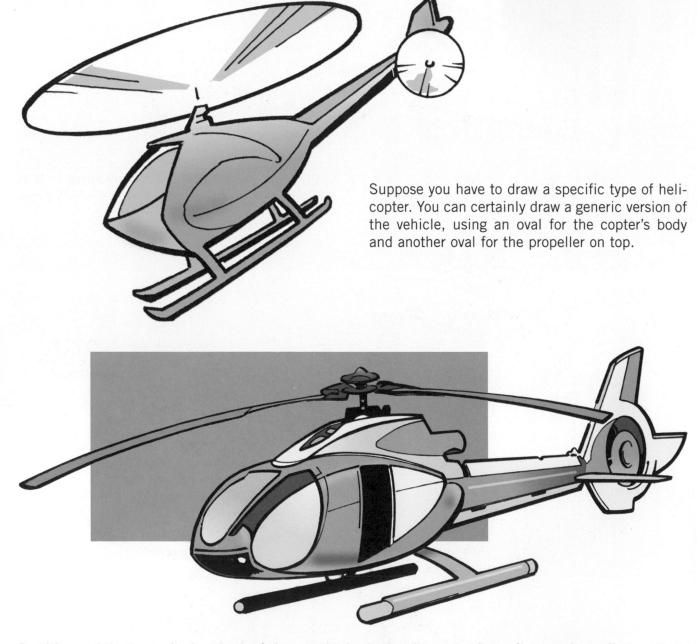

Suppose you have to draw a specific type of helicopter. You can certainly draw a generic version of the vehicle, using an oval for the copter's body and another oval for the propeller on top.

But it's much better to find a photo of that particular helicopter and refer to it to capture all the details correctly.

The same goes for this tank. The drawing above is OK, but it's really just a "cartoony" impression of how a tank looks. That drawing below is based on an actual photo of a real army tank—and is much more realistic and impressive.

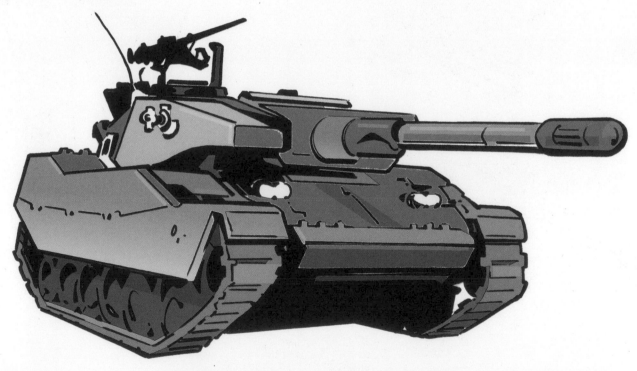

TIP: Use the Internet, newspapers, magazines, or any other picture source to find the reference images you need! Using reference photos will add authenticity and realism to your artwork.

If you're still running into problems, step back and take a deep breath. Just because your drawing's not quite right, it's *not* the end of the world! Many mistakes can be easily fixed once you've identified the problem. Let's take a quick look at some basic problems in figure drawing and see how they can be corrected.

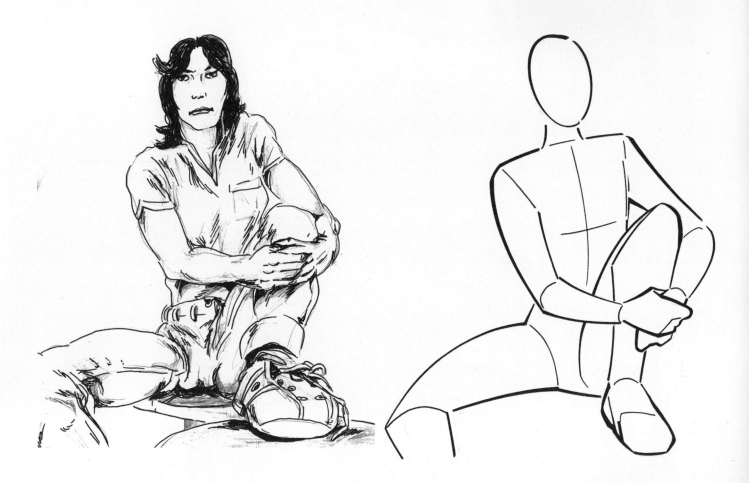

The poorly constructed figure on the left would have turned out better if the artist had started out with a better foundation of simple shapes, as shown on the sketch on the right. To repeat: Always begin a drawing by looking for those simply shaped building blocks, using them to create a well-proportioned starting figure. Do *not* begin with the surface details. They will always trip you up!

Still can't get your figure to look right? Feeling frustrated? Sometimes fixing a figure is as easy as adjusting the size of the head. Is the head too big or too small? Simply make the adjustment, and watch how the drawing suddenly seems just right!

Do you see the problem with this figure? Yep, that handsome head is just a tad too big, making Geminar seem childlike. (Compared with adults, children have somewhat "oversized" heads.) Just that one thing throws everything off!

Hands are among the most expressive parts of the body, but they can be hard to draw. They don't have to be, however. Just as when you're starting a figure drawing (or any drawing, for that matter), use basic shapes when sketching out a hand. Remember to keep it simple!

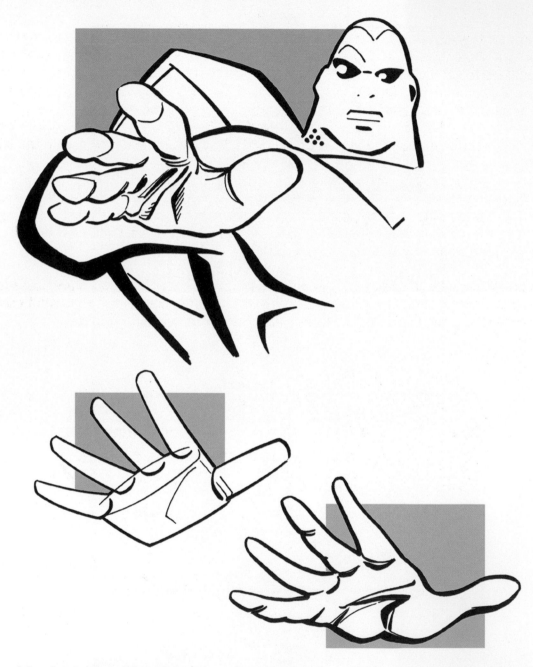

Here, the oddly shaped hand is redrawn by reimagining it as a block shape with five cylinders added. It can be that simple. Once you're satisfied with the start, flesh things out with a few details.

- Stuck for a pose—or having trouble getting a pose to look "real"? Ask a friend to pose for you! Whether you need to get the body language just right, or capture a certain facial expression, or just see how a hand looks when holding an object in a certain way, you can't beat working from real-life poses. And friends are usually willing to pose long enough for a quick sketch.

- Use a mirror! If you can't find someone to pose for you, pose for yourself! Set up a mirror where you can easily see yourself in it, and then make that funny face, grasp that object, or do whatever you need to get the drawing right. If you just need to reference a facial expression, you can even use a small mirror, holding it in your free hand. Sometimes all you need is that one quick sketch from the mirror to get you started or to work out that drawing problem!

- Take your time! Rushing is the main cause of smears and spills! (Also, try to keep the drawing area free from pencil shavings and eraser crumbs.)

- Trace! Never be afraid to learn by tracing. As long as you don't pass tracings off as your own original work, there's no harm in practicing this way. Tracing your favorite artists' drawings will help you see how they get their lines and effects. If you were studying music, you wouldn't close your ears to the work of other musicians, would you? Look and learn!

- Take a break! If you're frustrated by how a drawing's going, sometimes you simply need to stop and *relax* for a while. Do something else, come back later, and look at your work with fresh eyes. This may help you see how to fix those problems that seemed so unsolvable.

So what's next?

That's totally up to *you.*

It's up to you to keep drawing, always keeping your eyes open for new techniques and always being willing to experiment. For inspiration, look to the world around you—and to the work of other artists, both in and *outside* your area of interest. If you can, take art classes.

The real key to artistic success—to getting better and better—is just to *draw.* Practice. Draw and then draw some more. Sometimes your work will improve more quickly, sometimes more slowly, but over time you will see vast improvement if you just stick with it!

So it's all up to you. Keep drawing!

BEST,
—AL BIGLEY—